Interpreting Henri Rousseau

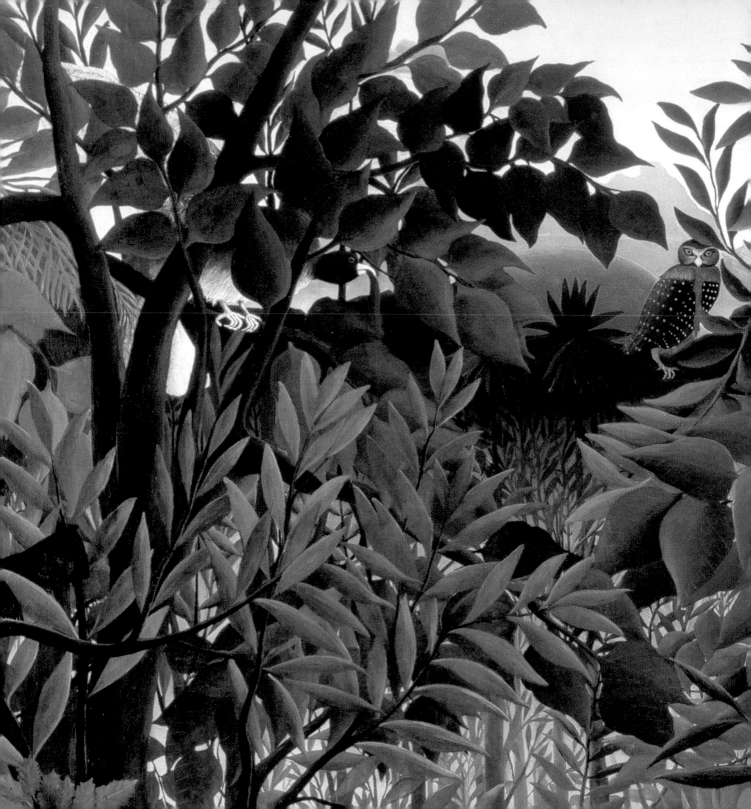

Interpreting Henri Rousseau

Nancy Ireson

TATE PUBLISHING

First published 2005 by order of the Tate Trustees
by Tate Publishing, a division of
Tate Enterprises Ltd,
Millbank, London SW1P 4RG
www.tate.org.uk/publishing

on occasion of the exhibition
Henri Rousseau: Jungles in Paris
at Tate Modern, London
3 November 2005 – 5 February 2006

and touring to:

Grand Palais, Paris
13 March – 19 June 2006

National Gallery of Art, Washington
16 July – 5 October 2006

Exhibition at Tate Modern supported by
Aviva PLC

British Library Cataloguing in Publication Data
A catalogue record for this book is available from
the British Library

ISBN 1-85437-615-2

Distributed in the United States and Canada by
Harry N. Abrams, Inc., New York

Library of Congress Cataloging in Publication Data
Library of Congress Control Number: 2005930847

Designed by Philip Lewis
Printed in Germany by Die Keure

FRONT COVER: *Tiger in a Tropical Storm (Surprised!)*
1891 (detail of fig.5)
BACK COVER: *Rousseau in his studio, 1907* (fig.33)
FRONTISPIECE: *The Hungry Lion Throws itself on
the Antelope* 1905 (detail of fig.8)

AUTHOR ACKNOWLEDGMENTS

For Hazel Ireson.

My thanks to the colleagues with whom I have
had the pleasure of working on *Henri Rousseau:
Jungles in Paris*. I am particularly indebted to
Christopher Green; his advice and enthusiasm
has been invaluable. I would also like to thank
Joy Weber, Christophe Tzara, the Musée du Vieux-
Château in Laval and the Fonds Delaunay, for
granting access to the documentation that has
shaped this small volume.

Contents

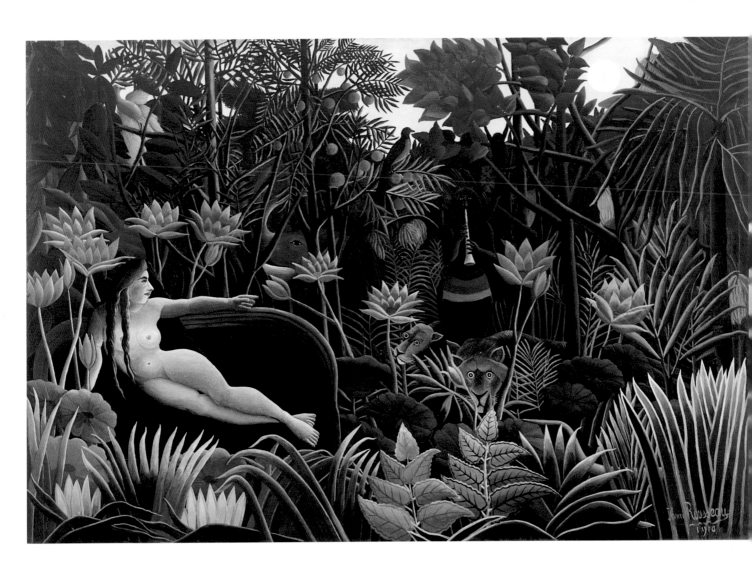

A Man and a Myth

Hear us Gentle Rousseau
We hail you
Delaunay his wife Monsieur Quével and I
Allow our baggage through freely at heaven's gate
We will bring you brushes colours canvases
So that your sacred spare time in the one true light
May be devoted to painting as you did my portrait
The face of the stars [1]

When Henri Rousseau died in September 1910 at the age of sixty-four, barely a dozen mourners attended his funeral. He left no money for anything but a pauper's grave and, save for his friends and a small number of collectors, few would have cared for the contents of his modest suburban studio. It is curious, then, that within a matter of months a new generation had come to recognise him as one of the most significant artists of their time. His works became exemplary models from which young painters could learn; his jovial and unsophisticated manners – once the butt of many a joke – now counted amongst his virtues. In 1911, when the Salon des Indépendants to which he had belonged held a commemorative retrospective, his paintings attracted much praise. And soon afterwards a group of artists and writers – including Robert Delaunay, Fernand Léger, Alexander Archipenko and even Auguste Renoir – came together and pooled resources to buy a proper tomb concession for the artist. [2] In this way, Rousseau eventually came to rest under the gravestone (fig. 4) now reinstalled in his birthplace, Laval.

After the death of the painter, the art dealer Wilhelm Uhde predicted that 'when the time comes to write the history of art for this era, the name Henri Rousseau will appear on the first page.' [3] For a time, at least, it seemed as though he might be right. Accordingly, throughout the 1910s and even into the 1920s and 1930s, many important artists and critics continued to see Rousseau as a key figure in the development of twentieth-century art.

1 **The Dream** 1910
Oil on canvas
204.5 × 298.5 (80 1/2 × 117 1/2)
Museum of Modern Art,
New York. Gift of Nelson
A. Rockefeller. 252.1954

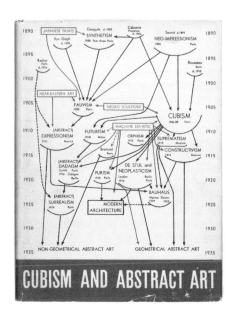

2 Alfred Hamilton Barr Jr.
Cover of the Exhibition Catalogue *Cubism and Abstract Art*, MoMA 1936
Museum of Modern Art, New York

3 **The Snake Charmer** 1907
Oil on canvas
169 × 189.5 (66 1/2 × 74 5/8)
Musée d'Orsay, Paris.
Bequest of Jacques Doucet, 1936

For them, he was (as Delaunay put it) 'the grandfather of the artistic revolution in Modern painting.'[4] But when the histories of early twentieth-century art were eventually written, Rousseau was sidelined. His strange paintings, like *The Dream* (fig.1) and *The Snake Charmer* (fig.3), looked quite unlike those by other modern artists. Furthermore, many believed he was an untutored amateur, a 'naive' who had painted for fun. Such information seemed incompatible with notions of artistic greatness and thus, even if his pictures featured in major museum collections around the world, Rousseau was set apart. He was, at best, an interesting anomaly. When, in 1936, the director of the Museum of Modern Art in New York drew up a diagram of how contemporary painting had evolved, Rousseau appeared alone, resting uneasily between movements, as an idiosyncratic episode in an unfolding story (fig.2). Since then, although more information about Rousseau's life has emerged, that status quo has remained largely unshaken.

But why was Rousseau marginalised? The tomb may offer some clues. Featuring a poem composed by Guillaume Apollinaire (one of the foremost young poets of the day), which was then inscribed by the sculptor Constantin Brancusi, the monument was every inch an avant-garde tribute to the painter. But it was also somewhat misleading. Apollinaire's

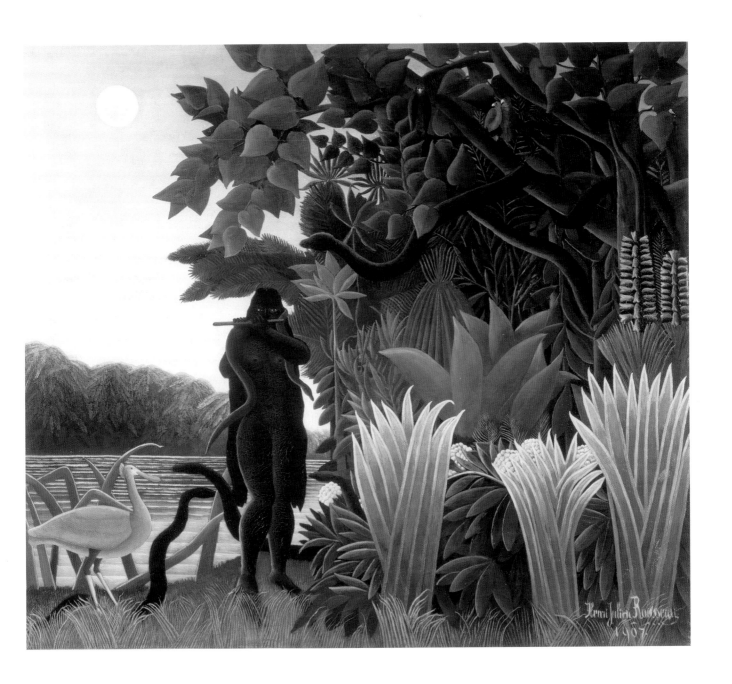

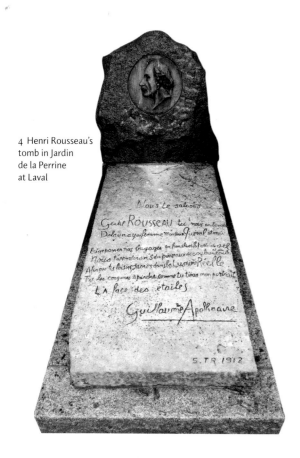

4 Henri Rousseau's tomb in Jardin de la Perrine at Laval

verse – with its reference to the artist waving luggage through tax-free at the gate of Heaven – paid homage to Rousseau *Le Douanier* or 'The Customs Man'. However, Rousseau had not been a customs man, but an employee of the *Octroi*: a municipal service that imposed duty on goods entering the city. What emerges is that the poem celebrated and consolidated an idea of the artist that, like his nickname, was not strictly accurate.

It is important not to blame admirers like Apollinaire for perpetuating stereotypes about Rousseau. It was largely thanks to their efforts that his name lived on. The books and articles written by the artist's avant-garde friends, even today, are invaluable resources for anyone who is interested in Rousseau and his work. But when these associates praised him, or found fault with him, they did so on their own terms and to suit their own agendas. This led to much myth-making; original accounts, retold, became anecdotal. To suit particular critical arguments they cast Rousseau as a 'naive' or 'primitive' artist, an 'artist of the people' or a painter in the French 'classical' tradition. But as time went on and the art world changed, these constructions became less relevant. Art history, unable to see beyond the myth, left Rousseau behind.

But what of the works themselves? Rousseau's paintings, in the twenty-first century, are still as exciting as ever. If, according to contemporary critics, crowds gathered before *The Hungry Lion Throws itself on the Antelope* at the Salon d'Automne of 1905, in 2005 there are always visitors grouped around his *Tiger in a Tropical Storm (Surprised!)* (fig.5) in London's National Gallery. And the story is the same in the Museum of Modern Art in New York, the Musée d'Orsay in Paris, or the Hermitage in St Petersburg. Audiences still stop and stare at these strange and marvellous paintings; they are, in the simplest sense, popular. But if his pictures posed difficulties for contemporary visitors to the Salon, even 100 years on they are no easier to decipher. Take, for instance, the *Happy Quartet* (fig.7) of 1901–2. The poet and writer André Salmon – a young contemporary of Rousseau – described it as one of the artist's most beautiful and important paintings, but could not explain why.[5] Here two nude figures stand in a wooded setting, the male playing a pipe, the female posing with a garland of flowers. This company (recalling groups of mythological or biblical figures)

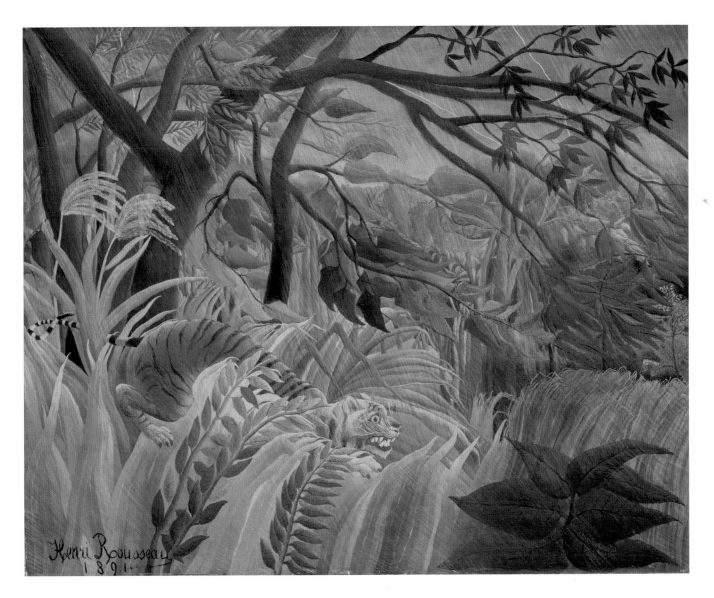

5 **Tiger in a Tropical Storm (Surprised!)** 1891
Oil on canvas 129.8 × 161.9 (51 1/8 × 63 3/4)
The National Gallery, London

should be, in theory, the very image of tranquillity. Yet in practice, the viewing experience feels dislocated and uneasy. The quasi-tropical plants in the foreground, superimposed onto the scene, seem somewhat out of place in this European-looking clearing. Why has Rousseau placed two semi-naked figures in what could easily be a park or garden? The cherub and the dog placed between the figures are no less confusing. They too seem at odds with the central section of the composition. The child, arrested mid-leap, almost collides with the leg of the musician; the woman glares at her companion while his gaze refuses to meet her eye.

There is nothing conspicuously 'modern' about the content of *Happy Quartet*; but the experience of looking at it is novel. Thus subject matter and appearance in Rousseau's work often seem contradictory. Even certain of his landscapes present a similar paradox to *Happy Quartet*. To paint, figuratively, an image of a villa in the suburbs as Rousseau did in his *House on the Outskirts of Paris* (fig.6) is not an extraordinary undertaking in itself. As a task, it might even appear banal, leaving little scope for creativity. How surprising then, is this small canvas, which takes an everyday scene

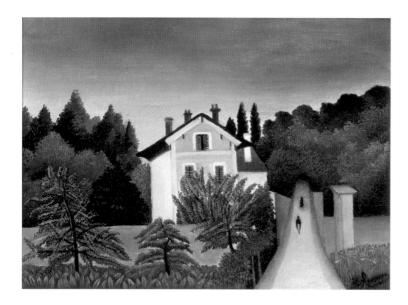

6 **House on the Outskirts of Paris** *c.*1905
Oil on canvas
33 × 46.4 (13 × 18 1/4)
Carnegie Museum of Art, Pittsburgh. Acquired through the Generosity of the Sarah Mellon Scaife Family, 1969

7 Happy Quartet 1901–2
Oil on canvas
94 × 57.4 (37 × 22⅝)
Greentree Foundation, New York

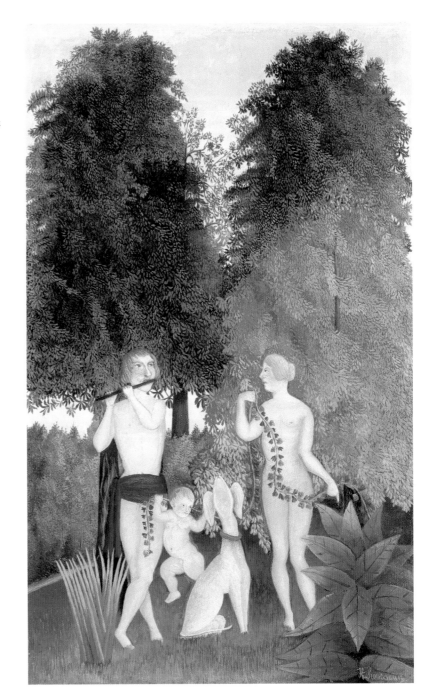

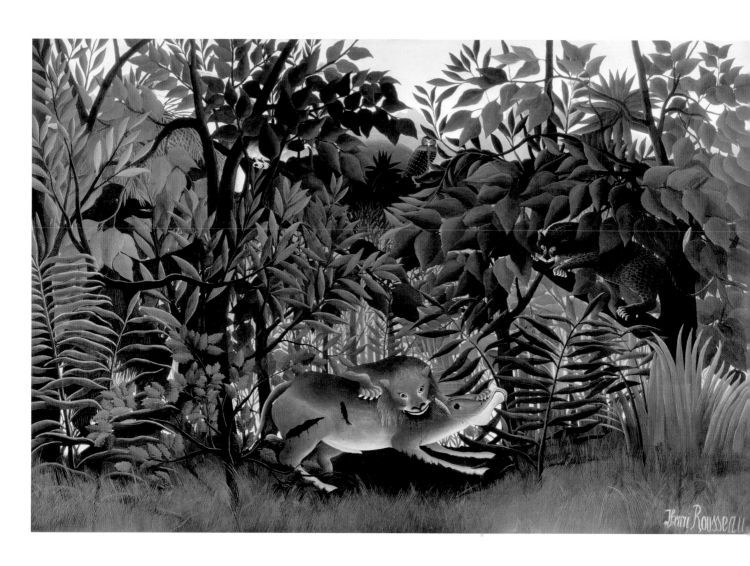

8 **The Hungry Lion Throws itself on the Antelope** 1905
Oil on canvas
200 × 301 (78³/₄ × 118¹/₂)
Fondation Beyeler, Riehen/Basel

and makes it strange? Alongside the house, curving both skywards and into the forest beyond, is the strangest of paths. Rousseau's most famous works, his celebrated jungle scenes, present a similar paradox. *The Hungry Lion Throws itself on the Antelope* (fig.8) depicts a bloody and brutal animal combat. But the plump, flesh-eating crows, the smiling big cat and crying victim, make the scene at once terrifying and comical.

What to make of such extraordinary images? Fortunately, though the look of the works remains the same, the task of 'interpreting Rousseau' may be easier with hindsight. There is, fortunately, an important difference between viewing Rousseau then and now. If in his lifetime and immediately afterwards the artist had seemed strange, it was not only because of the unusual look of his works. It was due to the way in which, as a person, he was quite unlike the people who praised him. 'I was young, from a completely different milieu', wrote Delaunay, one of his most ardent supporters.[6] People like Delaunay – who came from privileged families – were unaccustomed to the petite bourgeoisie, its manners, interests and motivations. Consequently, in their analysis, they tended to dwell upon Rousseau's character and to attribute the strangeness of his art to his personality. Both, no doubt, seemed rather exotic. At the turn of the last century, a time when definitions of art were very limited, the legend of Rousseau the unsophisticated 'Customs Man'– as celebrated on the gravestone – helped admirers understand and celebrate a new and bewildering art. Now, in a more liberal climate, such stereotypes are no longer required. In order to interpret Rousseau in the twenty first century it is necessary to go beyond the myth. It is time to look, instead, at the paintings themselves, at the environment in which he worked, at the people and purposes for which his images catered. In the light of that context, these strange canvases make much more sense, and their appeal to the avant-garde becomes clearer.

Overleaf: **The Dream** 1910
(detail of fig.1)

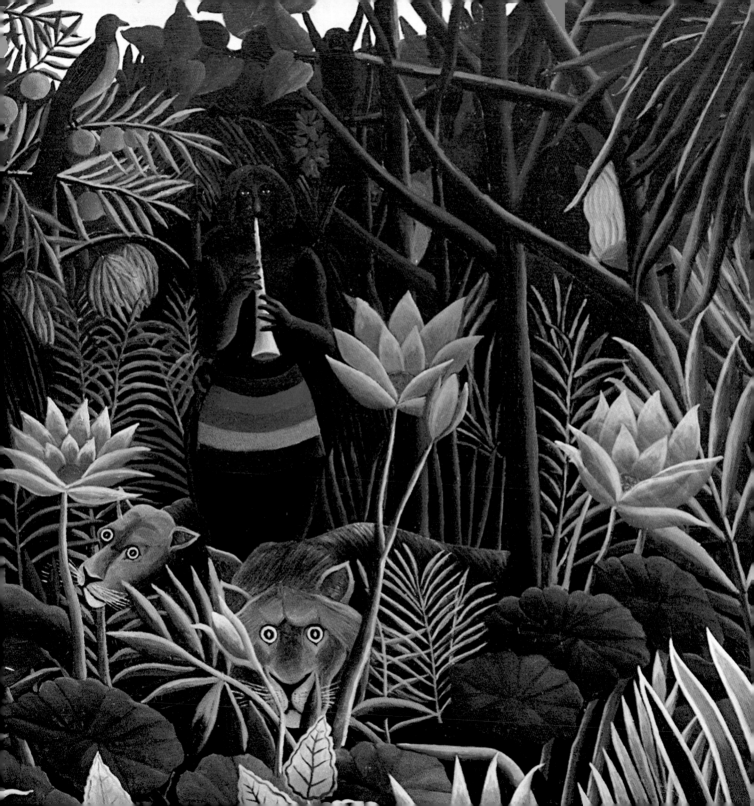

Rousseau's Early Years

There is no 'story' to Rousseau's life; it can be told
quickly. The lines and colours of his existence were
blurred, as with any humdrum life, bereft of adventure.
His days on this earth were those of a man who dreams,
modestly, of 'Life'. On this score, I see only 'the people'
with whom to compare him.[1]

Scant information survives about Rousseau's life, but it is clear that his
experiences were quite unlike those of his admirers. Of course, being
almost forty years older than Picasso, he belonged to another generation.[2]
But more than age separated Rousseau from the young painters who
championed his work: he had come from a very different background.

Rousseau was born in 1844, in Laval, a provincial town in northern
France. His family had upper-middle-class roots, but with an ironmonger
for a father, the artist's own upbringing was rather less grand.[3] He had
attended school until well into his teenage years – quite a luxury given
the household's modest means – but he had proved an unexceptional
student. He may have shown some talent for art, but even if this was the
case, he did not follow any kind of artistic training. In later years, in an
autobiographical statement written in the third person, he spoke of how
he was at first 'forced, owing to his parent's lack of fortune, to pursue a career
different from that to which his artistic tastes called him'.[4] To attend art-
school would have required a private income – the kind of funds that, many
years later, supported a number of his avant-garde friends in Paris.

Around 1861, when Rousseau was about sixteen, his family moved to
Angers. Unlike most young men, by continuing at school, he had avoided
compulsory military service. This meant that in 1863 he was free for civilian
work, at which point he joined the office staff of a local lawyer. But this
employment was short-lived. Faced with prosecution for stealing a large

9 Anonymous
Portrait of Henri Rousseau
*c.*1880
Gelatin silver print
13.5 × 10 (5¹/₄ × 3⁷/₈)
Fonds Delaunay, Paris.
Bibliothèque Kandinsky Research
and Documentation Centre at
the MNAM/CCI

10 **The Banks of the Bièvre near Bicêtre** 1908
Oil on canvas
54.6 × 45.7 (21¹/₂ × 18)
The Metropolitan Museum of
Art. Gift of Marshall Field,
1939 (39.15)

quantity of stamps and a small sum of money, Rousseau volunteered for
seven years in the forces. Before the age of twenty then, he already had
a criminal record for 'theft, fraud and abuse of confidence'.[5] He served
a short prison sentence in 1864 before rejoining his regiment. Decades
later – and perhaps encouraged by Rousseau himself – the painter's
admirers would make much of the artist's illustrious military career.
Had circumstances been different, however, he might never have
donned uniform.

After volunteering, Rousseau's time in service proceeded in an un-
remarkable fashion, his company moving from one regional training post

**11 Portrait of the Artist with
a Lamp** 1900–3
Oil on canvas 23 × 19 (9 × 7 ¹/₂)
Musée Picasso, Paris

or reserve camp to the next. At this point, certain of his comrades were posted to Mexico as part of France's unfortunate campaign in the 1860s. Rousseau, in contrast, never left his homeland.

In 1868, when the army acquitted him upon the death of his father, he saw the opportunity for change and moved to Paris. Rousseau was by no means the only one of his generation to leave the provinces in favour of the sights and sounds of the metropolis. Indeed, at the end of the nineteenth century, Paris was the only major modern city in France. It attracted vast numbers of the regional population, who went there to look for work, with hopes of prospering.[6] Perhaps the way in which the country and the city seem to meet in some of the landscapes that Rousseau later made, such as *The Banks of the Bièvre near Bicêtre* of 1908 (fig.10), was informed by that collective experience. Indeed, if he always painted himself as a smart city gent (as in his *Portrait of the Artist with a Lamp* [fig.11]), his visions of Paris remained decidedly provincial. His conversation too, as his friend the American painter Max Weber recalled, was 'picturesque and unsophisticated and not at all Parisian'.[7] Once more though, this was probably a matter of perspective, for if Rousseau was not an intellectual, neither was he a peasant. Laval was – and still is – a market town of reasonable size.

Once installed in the capital, Rousseau found work as a bailiff's clerk. Then, having fallen in love with the daughter of his employer, he married. His first wife, Clémence Boitard, was a seamstress. But, despite their combined resources, their life together was not an easy one: problems were caused both by their personal circumstances – ill health and cramped quarters – and by historical events. In 1870 France declared war on Prussia and by the autumn of that year German forces had surrounded Paris. Due to a compulsory conscription act, Rousseau was obliged to rejoin the military, though he saw no active service and was soon free to leave. Yet civilian life in Paris was far from easy: there was no communication with the outside world, extreme weather conditions, starvation and sickness. It was during these hard times that the couple's first child died while still a baby.

Only after Seige of Paris and the bloody civil war that was the Paris Commune did Rousseau's situation improve. Later that year he secured,

thanks to a family connection, a job with the *Octroi*. Following a short probationary period Rousseau became a civil servant: a respectable, lower-middle-class, state employee. The job brought with it subsidised housing and a steady, if not extravagant, salary. Both were, of course, very welcome. Rousseau would stay with the *Octroi* until 1893 when he could start drawing a small pension, at which time he retired to devote himself to his art. But before then, as an amateur, he had already started to paint. And, though he would have preferred to leave the civil service sooner, he did not see his occupations as contradictory. Indeed, he depicted a 'customs' post – perhaps akin to the one that he himself manned – in one of his early works, created around 1890 (fig.12).

The Customs Post is unique, as his only painting that alludes to his time at the *Octroi*, but it is by no means the first of Rousseau's canvases. Though there is no record of an exact date, it is likely that he started painting in the early 1880s, for by 1884 he had obtained a permit to copy works in the Louvre and other Paris museums. He exhibited in public for the first time in 1885, the same year he managed to rent his first studio. The earliest of his identifiable exhibits, however, is from 1886. This picture, *Carnival Evening* (fig.13), baffled the few writers who commented upon it; but – as many critics have noted – the detailed brushwork and coherent composition suggest that he was already a competent painter by this date.

However, until a few years earlier, there had been no exhibiting venue for artists like Rousseau. Had it not been for the Salon des Indépendants – a newly established exhibiting society – his paintings would have gone unseen. Unlike the government salon, the Indépendants was jury-free, open to any artist. Upon payment of the small annual fee, Rousseau was able to display his efforts. Indeed, until his death in 1910, he would do so almost every year. He began to keep a scrapbook, pasting in press cuttings that referred to his exhibits, adding his own comments. Even negative attention was, to him, proof of a blossoming fame.[8] Here, from the very start, was an artist who anticipated greatness and who was supremely confident in his own abilities.

Yet, if these early moments in his painting career brought excitement, in his personal life he met with sadness. Clémence died from tuberculosis

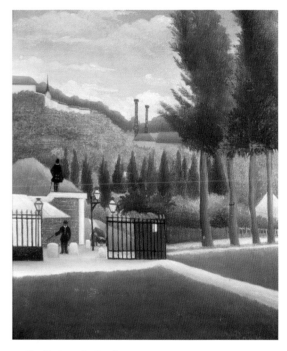

12 **The Customs Post** *c.*1890
Oil on canvas
40.6 × 32.7 (16 × 12 7/8)
The Samuel Courtauld Trust,
Courtauld Institute of
Art Gallery, London

13 **Carnival Evening** 1886
Oil on canvas
117.3 × 89.5 (46 1/8 × 35 1/4)
Philadelphia Museum of Art.
The Louis E. Stern Collection,
1963

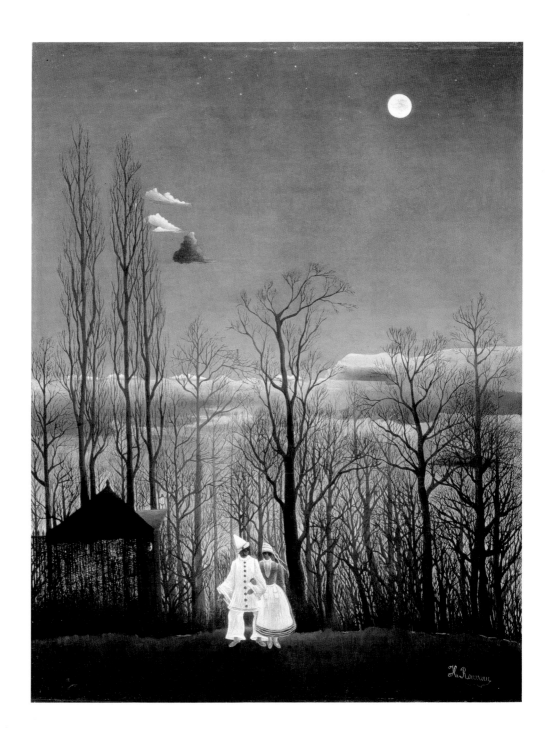

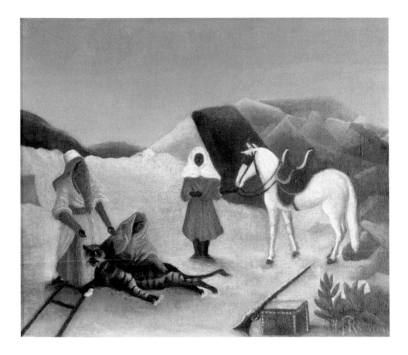

14 **Tiger Hunt** *c.*1895
Oil on canvas
38.1 × 46 (15 × 18 1/8)
Columbus Museum of Art, Ohio.
Gift of Ferdinand Howald

in 1888 and Rousseau found himself alone to care for a teenage daughter – the only one of the couple's eight children to reach adulthood. At this point, according to Uhde, the artist adopted a bachelor lifestyle; a play he wrote at around the same time features the risqué Monmartre night spot *Le Chat Noir*.[9] His daughter – unsurprisingly – soon went into the care of relatives.

Such moments in Rousseau's biography reveal how important it is to be wary of preconceptions about the painter as an innocent. It is clear that he himself played an active part in creating his image. For instance, following another run-in with the law, he would later write to a judge to describe what an exemplary life he had led; in doing so he elaborated upon the subject of his early career. He had, he claimed, frequented 'neither cafés nor cabarets'. As for his daughter, he explained, he had sent her to grow up in the countryside for the good of her weak health.[10]

Thus, in the literal sense, Rousseau was not naive: nor were his paintings. He had no artistic training, but he was reasonably well-educated and aware of contemporary art-world events. The 'innocence' in his canvases – just like the 'innocent' life he depicted in his letters – was partly of his own invention. Some of the painters whom Rousseau admired –

commercially successful ones who won state patronage – may even have encouraged him to paint in a 'naive' way.[11] 'Naïveté', as well as being the unconscious product of a clumsy hand, could also be a quality to nurture – a sign of sincerity that appealed to the romantic ideals of some late nineteenth-century artists. During these formative moments of his artistic career, he lived in the same street as Félix-Auguste Clément, an official prize-winning painter who may well have given him advice. Some of Rousseau's early works such as *Tiger Hunt* (fig.14) even suggest the influence of masters such as Jean-Léon Gérôme and Eugène Delacroix.[12] At least in the early stages of his career, Rousseau looked up to artists like these. He tried to emulate their compositions and he used similar subject matter. In 1891, he created his first jungle picture, *Tiger in a Tropical Storm (Surprised!)*(fig.5). In some ways here was a precursor to his later jungle combat scenes; but it is worth noting that lions and tigers had featured regularly in many important Salon paintings.

By 1890, it is clear that Rousseau thought of himself as a modern artist, because he described himself as one in a large self-portrait that he submitted to the Indépendants. There, in the canvas known as *Myself, Portrait-Landscape* (fig.15), he painted himself before the recently completed (and still controversial) Eiffel Tower: imposing, confident and proud. His painted self literally dominates the Parisian skyline, grand and imposing, like the kind of figure he intended to cut in the art world. But the art world in which he sought to place himself was not an avant-garde one; it was precisely that official arena that he so respected. The artist depicted himself smartly dressed, wearing a beret, complete with the tools of his trade. To any painter keen to defy convention, this vision would have seemed outmoded, even laughable. But, at the outset of his career, Rousseau would not have been bothered by such a concern. He was aiming high in order to attract an honour frequently bestowed upon his 'academic' idols: that of state patronage.

Rousseau's personal convictions would have motivated him in such a mission. Like so many petit-bourgeois city-dwellers, having lived through war and civil conflict, he was highly patriotic. He was a firm believer in Republican policies, optimistic about both his own future and that of his country. In theory, furthermore, he had good reason to be

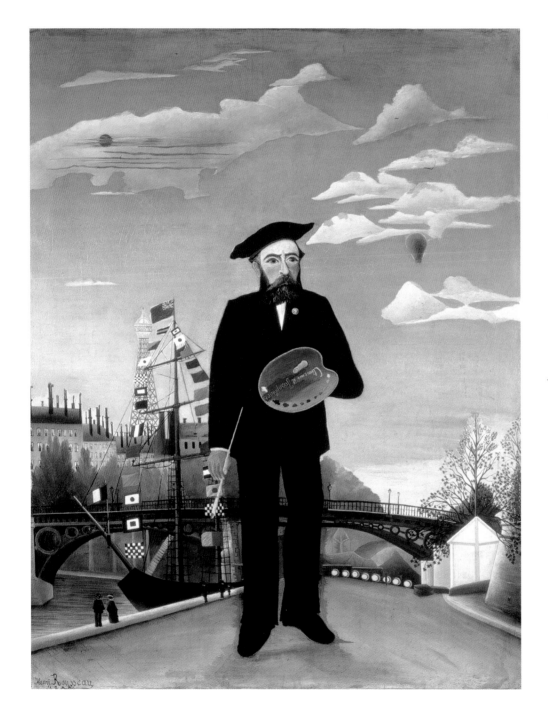

15 Myself, Portrait-Landscape
1890
Oil on canvas
146 × 113 (57 1/2 × 44 1/2)
National Gallery, Prague

hopeful of a positive reception for his new art. The end of the nineteenth century was a good time to be an innovative painter. New political ideas required new kinds of artwork and so, for a time at least, there was no one 'official' way of painting.[13] Unfortunately, in practice, that liberalism would never go so far as to embrace a style like his.

Nevertheless, undeterred, Rousseau entered government painting competitions. One of his entries – for a contest to decorate the town hall in the Paris suburb of Bagnolet in 1893 – was a version of his 1892 canvas *A Centennial of Independence* (fig.16). In some respects, this design was quite appropriate, for it could not have been more pro-Republican. In a scene seemingly as traditional as the depictions of religious festivals that the work would have replaced with its new, secular decorative scheme, Rousseau showed 'the people' dancing around the tree of liberty, dressed in the bonnets of French revolutionaries.[14] In the catalogue that accompanied its exhibition at the Salon des Indépendants, he added that the company was singing a traditional folk song, some of the lyrics to which he printed. But the judges, no doubt with conservative aesthetic tastes, turned down the image. Meanwhile such obvious political content may have discouraged other viewers.

However, unlike avant-garde painters, who could often divorce themselves from commercial concerns, Rousseau had good reason to try to please the authorities. An artist could make a good living in this way. Paintings in the official exhibitions sold for considerable sums. Had he won one of the government competitions, Rousseau would not have had to wait until 1893 to retire, for the prize money would have eclipsed his pension. The winner of the Bagnolet competition gained the grand sum of 43,000 francs; a starting salary for a junior employee of the *Octroi* at that time was just 1,000 francs.[15] It is hardly surprising that the artist, with his meagre income, was desperate to win. His friend the painter Robert Delaunay later remembered how, when talking about such projects, Rousseau's voice filled with passion. 'You could feel all his application, all his hope to have such a task to complete. Because he was aware of power, of its value.'[16]

Rousseau was in awe of official glory. Perhaps for that very reason he waited until 1894 – when he retired and became a professional artist –

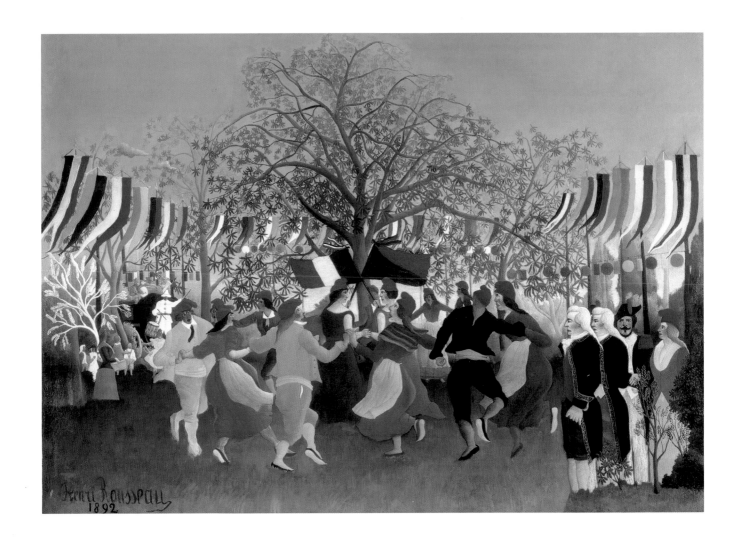

before he painted his first allegory. Allegory was the most ambitious of
the academic genres; one that would require the concentrated efforts
of a full-time painter. The resulting canvas, which he showed in the
Indépendants that spring, was his most complex work to date. *War*
(fig.17) is nearly two metres wide. At such a size, with so serious a theme,
it is clear that the piece was intended as an 'official' painting, designed for
display in a gallery or other large space. As was customary in such cases,
a few explanatory lines accompanied the image in the exhibition catalogue:

16 **A Centennial of Independence** 1892
Oil on canvas
111.8 × 157.2 (44 × 61⁷/₈)
The J. Paul Getty Museum,
Los Angeles

17 **War** 1894
Oil on canvas
114 × 195 (44⁷/₈ × 76³/₄)
Musée d'Orsay, Paris

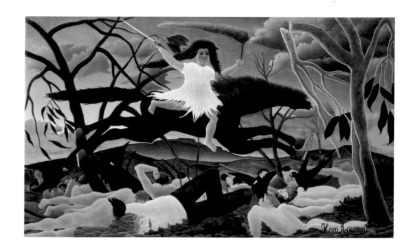

'*War*: terrifying she passes by, leaving behind on all sides despair, tears and ruin.' The dramatic verse did nothing to attract a state purchase but, significantly, the painting did win Rousseau his first positive avant-garde reviews. The young playwright Alfred Jarry and a painter called Louis Roy both noted and praised the canvas.[17]

Jarry set a precedent for how Rousseau's 'official' art might, in future, suit avant-garde agendas. He saw that the artist could reveal the ridiculous aspects of the 'official' imagery that he emulated. Here was an old man who, by aspiring to please the state, produced images with anarchic potential. Why would a woman on horseback, dressed in rags and with wild hair, be riding across this scene of death and destruction? In a more sophisticated rendition of the scene, the question might not pose itself, but Rousseau's picture, with its bold lines and violent colour, makes the scenario seem completely implausible.

Jarry's support, however, would not be enough to make a substantial difference to Rousseau's immediate fortunes. He provided the artist with a commission in 1895 – a print of the canvas to illustrate his journal *L'Ymagier* – but he was young and had financial troubles of his own. Thus, though Jarry's support of Rousseau would be of considerable importance to his admirers in later years, its immediate consequences were limited. For the time being Rousseau would have to make a living selling small, affordable works to patrons with more modest budgets.

Overleaf: **Carnival Evening** 1886
(detail of fig.13)

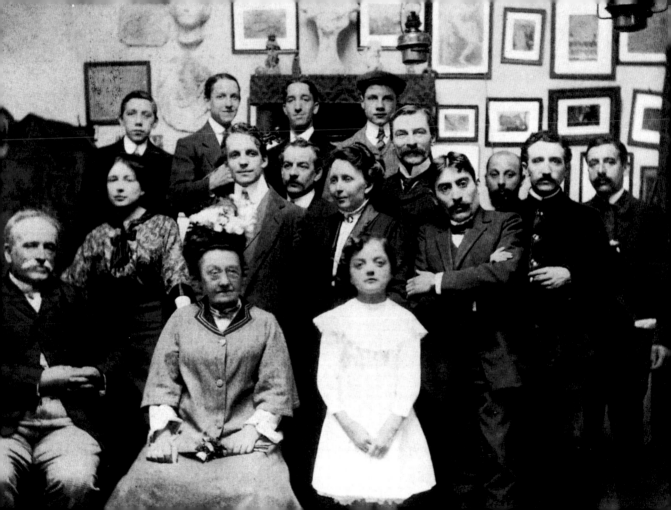

Art and Life in Paris

A violin-playing painter surrounded by friends:
Madame Bourges, the neighbourhood greengrocer,
Monsieur Louis Leblond the locksmith, his wife
and his girls.[1]

18 Van Echtelt
**'Le Douanier' and friends in
his studio** c.1910
Gelatin silver print
11 × 14.6 (4 3/8 × 5 3/4)
Musée d'Orsay, Paris

Before he became involved with the avant-garde art world in earnest (1905 or thereabouts) and with state patronage continually escaping him, Rousseau could only hope for the custom of the petite-bourgeoisie. The idiosyncratic appearance of certain works may make more sense in the light of this consideration; no other major modern artist, no Braque or Picasso, catered for such a humble market.

Clearly, of course, Rousseau would not have expected his neighbours to purchase his allegories or jungle scenes. For one thing they were too expensive; the letters he wrote to officials, requesting state purchases, prove that he planned to achieve considerable sums for such canvases.[2] In format, too, those works were clearly made for public display. His landscapes, in contrast, would have suited more modest settings perfectly. These works were smaller, decorative and picturesque, far more fitting for a living room or office.

Nevertheless, even if they were unlike the pieces that the artist destined for an 'official' market, Rousseau's landscapes still reflected Republican ideals. With slight disdain, Christian Zervos would later observe that, in his political and social opinions, Rousseau had 'the candour of a man of the people, which reduces the most complex problems of modern society to a few simplistic images'.[3] No strata of society was more pro-government than Rousseau's class and most Parisians were staunchly Republican at the time; in the 1880 elections over ninety percent

of the city's turn-out had voted Republican. These people had lived through a tumultuous period of France's history; now they looked to the government to ensure peace. In Rousseau's grand works, the Republic appeared as an ideal; one that delivered liberty of life and thought. The landscapes he painted showed the effects of that government as a patriot would have understood them: a tranquil, contented France where the sun is always shining and where even soldiers – like those in his *The Artillerymen* of *c*.1893–5 (fig.19) – seem free from danger. These were not images made as propaganda: they were simply born of a particular historical context. If Rousseau's works were pro-government, it was hardly surprising: so too were the people around him.[4] It is because of this that, considered in relation to this historical background, their choice of focus makes more sense.

Take *Saw Mill, Outskirts of Paris* (fig.20), for instance, painted *c*.1893–5. Here, Rousseau depicted a timber-cutting factory set in a rolling landscape;

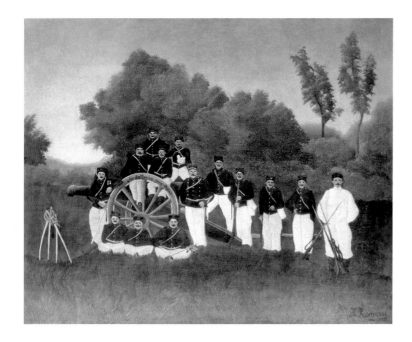

19 **The Artillerymen** *c*.1893–5
Oil on canvas
79.1 × 98.9 (31⅝ × 38⅞)
Solomon R. Guggenheim
Museum, New York. The Gift of
Solomon R. Guggenheim, 38.711

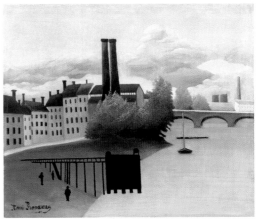

**20 Saw Mill, Outskirts
of Paris** *c.*1893–5
Oil on canvas
25.5 × 45.5 (10 × 17 $^5/_8$)
The Art Institute of Chicago.
Bequest of Kate L. Brewster

21 The Environs of Paris 1909
Oil on canvas
45 × 53.7 (17 $^3/_4$ × 21$^1/_8$)
Detroit Institute of Arts.
Bequest of Robert H. Tannahill

it is evidently busy, for outside there are vast piles of treated logs. Any post-war society values industry and, read literally, the picture suggests that France is prospering. But if it was 'modern' of Rousseau to paint such an unusual subject, he presented that modernity as unremarkable, as part of a natural order. The fact that the building blends in with its surroundings, that its presence does not disturb the promenading mother and child, makes the factory an acceptable part of the landscape. And, if the Republican celebration that Rousseau painted in his A *Centennial of Independence* (fig.16) was a secular alternative to traditional religious festivals, his *Saw Mill* depicted an industrial site with the kind of reverence previously reserved for churches. Elsewhere, in paintings such as *The Environs of Paris* (fig.21), chimneys appear where steeples might once have dominated.

But Rousseau's landscapes did not appeal simply because they mirrored a particular moment in time. They were also decorative; they were comparable to the folk art and popular prints that had traditionally furnished petit-bourgeois homes. *The Orchard* (fig.22) is a case in point: its primary colours and quaint subject matter might have deliberately invited such associations. Even when Rousseau identified the location that he had depicted in any given landscape, contemporary photographs show that he seldom presented his chosen locations with topographic accuracy. Rousseau did not paint Paris as it was, as a city that was under-going great changes, including the construction of the metro and the

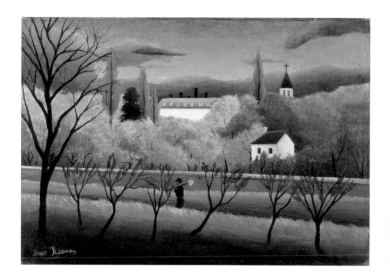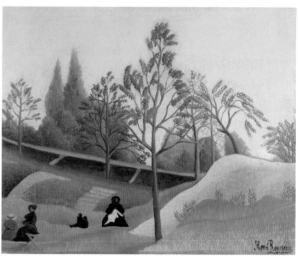

22 **The Orchard**
*c.*1896
Oil on canvas
38 × 56 (15 × 22)
Harmo Museum, Nagano, Japan

23 **View of the Fortifications**
1896
Oil on canvas
38 × 46 (15 × 18 1/8)
Private Collection, Switzerland

development of the department stores. Perhaps because the petite bourgeoisie was fuelling those changes, for their relaxation, Rousseau presented them with scenes that were infinitely more sedate, such as his *View of the Fortifications* (fig.23). After a hard day's labour, it was there, according to Uhde, that the shop workers and tradesmen headed 'to see a freer, fuller sky'.[5] Nevertheless, perhaps the strange leaps in perspective and the uneasy relationship between ground and figures reflects the fact that these images were dislocated from the actual look of the city.

One of the biggest transformations of the city's appearance, within the centre of the metropolis, was the Paris World Fair of 1889. This was a truly extraordinary event, which brought together all kinds of French and foreign exhibits on the streets of the city: 'African villages' filled the Trocadero; Swiss chalets and Javanese pavilions lined the banks of the Seine (see figs.24, 25). Rousseau was surely as excited by the event as the rest of Paris and, if he did not refer to it in his painted works, the Fair did provide the inspiration for his first completed play. Thus, shortly after the death of Clémence, he produced a manuscript entitled *A Visit to the 1889 World Fair*, no doubt hoping to ride on the coat-tails of the event's success.

As with the landscape paintings, like the World Fair itself, Rousseau meant the content of his play to appeal to the people of the city. A comedy, it described a group of country visitors from Brittany, on a trip to the great event. Their subsequent mishaps and adventures form the substance

25 View of the Seine during the 1889 World Fair. Photograph: Centre des Monuments Nationaux, Paris

24 Javanese village at the Paris World Fair of 1889 Photograph: Centre des Monuments Nationaux, Paris

of the play. 'Oh, it's so beautiful, that big ladder over there', exclaims one of Rousseau's little group of tourists, upon seeing the Eiffel Tower. 'It's higher than the Church Bell Tower at home. Oh, it is funny, but how do you climb up to the top? The rungs aren't round and they're all askew.'[6]

Of course, like so many of his petit-bourgeois contemporaries, Rousseau himself had come from the Provinces. His young friend Robert Delaunay was thus tempted to see the play in terms of the artist's own experiences: 'Didn't he himself arrive at the same station, from his village, attracted by city life?'[7] But, crucially, the fact that Rousseau could make fun of a group of theatrical peasants suggests that he did not see himself in the same light. *The Wedding* of 1904–5 (fig.26) makes the point eloquently. To compare this work to his *Portrait of the Artist with a Lamp* (fig.11) is to see that here it is the young city types, not the elderly couple in the foreground, who resemble the painter. He evidently thought of himself as cosmopolitan, quite different from the rural types he depicted in his composition.

Before he painted *The Wedding*, ten years after the death of Clémence in 1899, Rousseau had already married his second wife, the widow

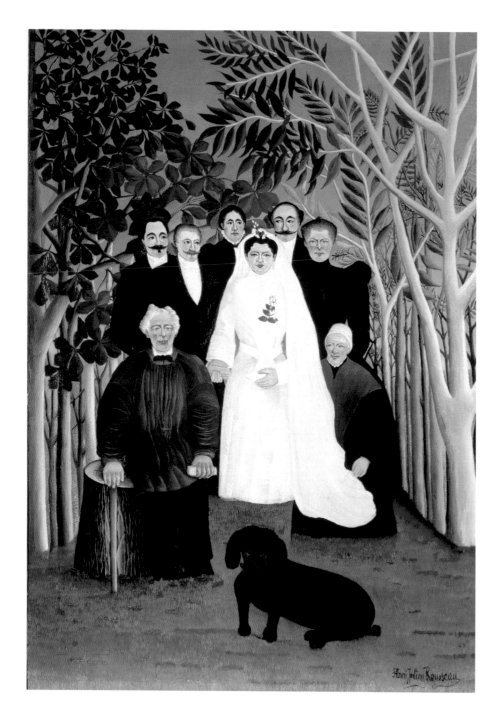

26 **The Wedding** 1904–5
Oil on canvas
163 × 114 (64$^{1}/_{8}$ × 44$^{7}/_{8}$)
Musée de l'Orangerie, Paris

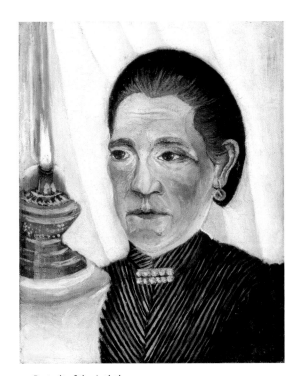

27 **Portrait of the Artist's Second Wife with a Lamp**
1900–3
Oil on canvas 23 × 19 (9 × 7 1/2)
Musée Picasso, Paris

Joséphine Noury. He joined her at her stationary shop in the Rue Gassendi where, along with the usual merchandise, they sold his pictures. Perhaps the upheaval of the new arrangement left him little time for painting; notably he did not submit his works to the Indépendants in either 1899 or 1900.

This is not to say, however, that his creative efforts stopped at this point. Joséphine and Rousseau made quite a team; in 1889, it seems likely that they tried to write a play in co-authorship, again on a popular theme. Clearly, as the Dada poet Tristan Tzara would later observe, Rousseau was essentially a modern 'Renaissance' man: someone who considered all arts equal.[8] The resulting work, *The Revenge of a Russian Orphan*, was a story about deception and justice in love.[9] Its dramatic tone and its German villain were once again perfectly in keeping with contemporary norms. Despite this, as was the case with Rousseau's earlier effort, the piece went unpublished until long after the artist's death.[10] Following the play's rejection, it was no doubt with regret that in 1900 the painter had to take on menial work, as a neighbourhood sales representative for the illustrated review *Le Petit Journal*.

But if the turn of the century did not bring Rousseau commercial success, he did produce some of his most remarkable paintings in the first years of the new decade. At some point between 1900 and 1903, Joséphine would provide Rousseau with the inspiration for a pair of paintings that would become two of the artist's most iconic images. Though never exhibited during his lifetime, *Portrait of the Artist with a Lamp* (fig.11) and *Portrait of the Artist's Second Wife with a Lamp* (fig.27) would feature in the 1911 retrospective, where they attracted the admiration of the young artists who saw them. Later, they were owned both by Delaunay and Picasso.

These pendant portraits count amongst the most intense studies that Rousseau ever produced, with the faces of both subjects defined in meticulous detail, set against the plainest of backdrops. The composition is simple; the only additional detail, in each image, is a burning oil lamp. Why, then, did he choose not to exhibit them? Neither appears in any of the Salon catalogues. He must have intended these paintings, with their personal subject matter, for private display.

The 'lamp portraits' thus introduce another way in which Rousseau might have tried to cater for a neighbourhood clientele. In their format – head shots with blank backgrounds – both resemble the small portrait photographs that were so popular at the end of the nineteenth century amongst the petite bourgeiosie.[11] Photography was a relatively new development; for the first time, by visiting one of the various studios that were springing up across the city, people on a modest salary could acquire a likeness of their nearest and dearest. The formal photographs that people brought – *cartes de visite* as they were known – served several functions. They were keepsakes, mementoes of likeness, aide-memoirs. They were private images, to send to relatives, to carry in a pocket or prop on a desk. And of course, at that time, the very genre of photography was a novelty.

Some of the qualities of the *carte de visite* photograph suggest different ways in which to understand portraits by Rousseau. Like photographs, these images were potentially affordable. Like them they had a sentimental draw that, in this case, could inflate their value to particular clients. According to Uhde, the artist sold his *To Celebrate the Baby* (fig.28) to the child's parents for 300 francs, considerably more that many of his works achieved.[12] As André Salmon pointed out, these buyers were not so much collectors of Rousseau's works as they were fans of their own offspring.[13]

Yet, unlike portrait photographs, with their ungainly proportions, Rousseau's paintings could hardly have provided an accurate sense of visual likeness. What exactly, then, was their appeal? If it is easy to understand how petit-bourgeois audiences could have found Rousseau's landscapes attractive, comprehending his portraits is more difficult. But Uhde explained that, in painting a portrait, Rousseau took little interest in the appearance of a person. Instead, he wished to capture the inner self: he used *Portrait of a Woman* (fig.29) and *Child with a Doll* (fig.30) as illustrative examples. Rousseau, Uhde explained, could capture something about the person's character that went beyond looks. If this were the case, then Rousseau's portraits may have provided an even more effective way of remembering someone: often they featured personal details that only a loved-one might have recognised. A poem that Rousseau wrote to accompany an image that may be his *Portrait of*

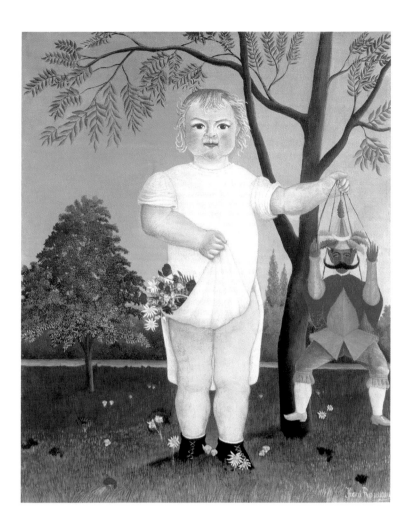

28 **To Celebrate the Baby**
1903
Oil on canvas
100 × 81 (39 3/8 × 31 7/8)
Kunstmuseum Winterthur,
Inv. Nr. 1103. Presented by
the heirs of Olga Reinhart-
Schwarzenbach

a Lady (fig.32), for example, explains that the parasol held by the sitter
was a present from her husband: the portrait may well have been his
commission.[14]

Rousseau seems to have had a few faithful clients for such works. In
a list of his entries to the Indépendants over the years, there are several
mentions of a Monsieur and Madame M., a Monsieur and Madame L.,
perhaps contented sitters who provided frequent portrait commissions.
But, however well-pitched his images were for a petit-bourgeois clientele,
many still thought him eccentric or ridiculous.[15] Even as early as 1895, the

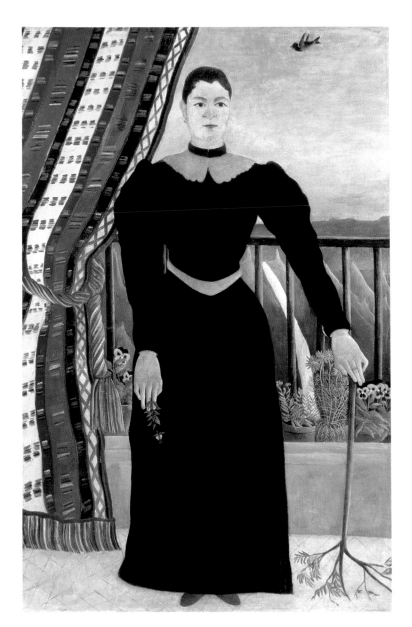

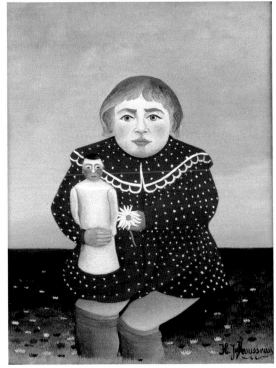

29 **Portrait of a Woman**
1895
Oil on canvas
160 × 105 (63 × 41³/₈)
Musée Picasso, Paris

30 **Child with a Doll**
c.1904–5
Oil on canvas
67 × 52 (26³/₈ × 20¹/₂)
Musée de l'Orangerie, Paris

artist looked to sell his works to a different market, by putting his pictures on consignment with the dealer Ambrose Vollard.[16] As his patron Roch Grey (the Baroness d'Oettingen) observed, despite all his 'popular' qualities, Rousseau's way of describing things left him 'solely accessible to the elite'. Educated sophisticates with advanced tastes were the greatest champions of his art.[17]

Nevertheless, regardless of what they thought of his painting, Rousseau was friendly and often invited his neighbours into his home, Here they would talk or share a frugal meal. Uhde described one of these get-togethers at the studio, when, dressed in his best clothes, the artist would play host to the locals. Guests would sit around his latest work, giving their comments and making suggestions as to how he could improve: 'You need to make the leaves in the foreground darker.' On such occasions, following those discussions, the guests would leave contented, satisfied that they had shown 'that they are knowledgeable about painting, perhaps even more so than the artist himself'.[18] Clearly, then, if these visitors enjoyed Rousseau's work they were hardly reverential. The only people who recognised 'Le Douanier' as a genius were intellectuals and painters.

But Rousseau may have gained some respect from his immediate peer group, not as a painter or writer, but as a musician. He sang and he played both the violin and the flute (see fig.31). In 1904, he even managed to publish *Clémence*, a waltz that he had composed in memory of his first wife (though his second wife Joséphine had also died the year before). Aside from painting, Rousseau's musical talent provided his most sustainable income after his retirement, for it allowed him to give lessons in his home. When he eventually moved to a new permanent address in 1905, to a studio in the Rue Perrel, he put a plaque on his door to advertise his classes.

Rousseau must have enjoyed teaching, or at least have felt that it was of social value, because he gave free classes at the city's adult education establishments. In 1901, his name appears in a government listing, as a teacher of drawing and ceramic painting. But the only existing accounts of what his classes were like date from after he moved again, this time to the quiet suburban district of Plaisance, for it was at around this time that

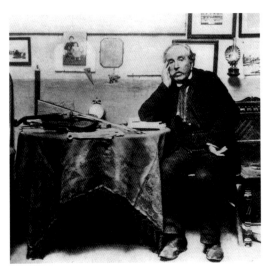

31 Rousseau with his violin in his studio at Rue Perrel *c.*1908 (The photograph bears a dedication to Max Weber)

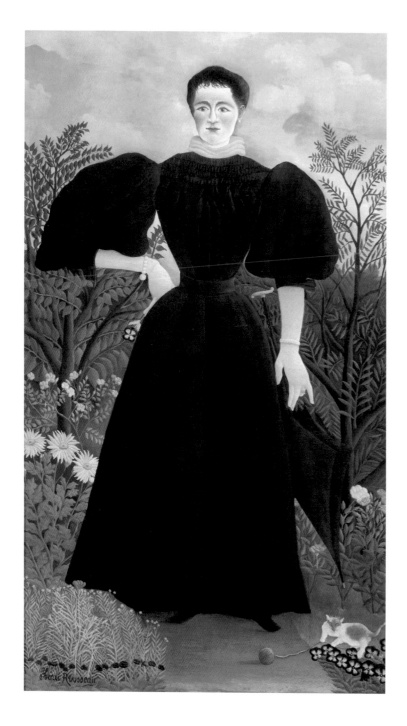

32 **Portrait of a Lady** 1895–7
Oil on canvas
198 × 115 (78 × 45 1/4)
Musée d'Orsay, Paris.
Donation of Baronne
Eva-Gebhard-Gourgaud, 1965

the bourgeois intelligensia became interested in his work. It was here that people like Uhde, Apollinaire and Roch Grey would visit the artist. Their writings explain how he would take on all ages of student. The oldest, apparently, was a man of seventy-four. Most, however, were local children, who would tease their teacher and misbehave during exams.[19]

But, even if teaching had its pitfalls, music was a source of pleasure for the artist. He played in his spare time and at the *soirées* he held in his studio. He would send out invitations and print special programmes for these evenings; the performers would include himself, his pupils and his friends. As time went on the mixture of guests became increasingly eclectic, petit-bourgeois neighbours mixing with poets and painters. At a special musical evening that 'Le Douanier' hosted when Max Weber was due to return to America, both Weber himself and Madame Quevel (the wife of Rousseau's landlord) featured amongst the performers.[20] It must have made for an extraordinary company, with the locals listening in earnest to their children, while the more sophisticated of the guests looked on in gentle amusement. Weber recalled many years later that Rousseau 'was not endowed with a rich and powerful voice' and that 'he sang quaint ancient French folk-songs with an intimacy and warmth such as only a loving son of France could have sung. He played his violin unlike anyone else I have ever seen before or since. A technique positively all his own – his unique manner of fingering.'[21] By contrast, Weber himself had a good tenor voice and was a trained singer. Two diverse 'worlds' – the petit bourgeois and the intellectual – came together at Rousseau's *soirées*. Other worlds, equally different, would likewise meet in his jungle paintings.

Overleaf: **The Wedding** 1904–5
(detail of fig.26)

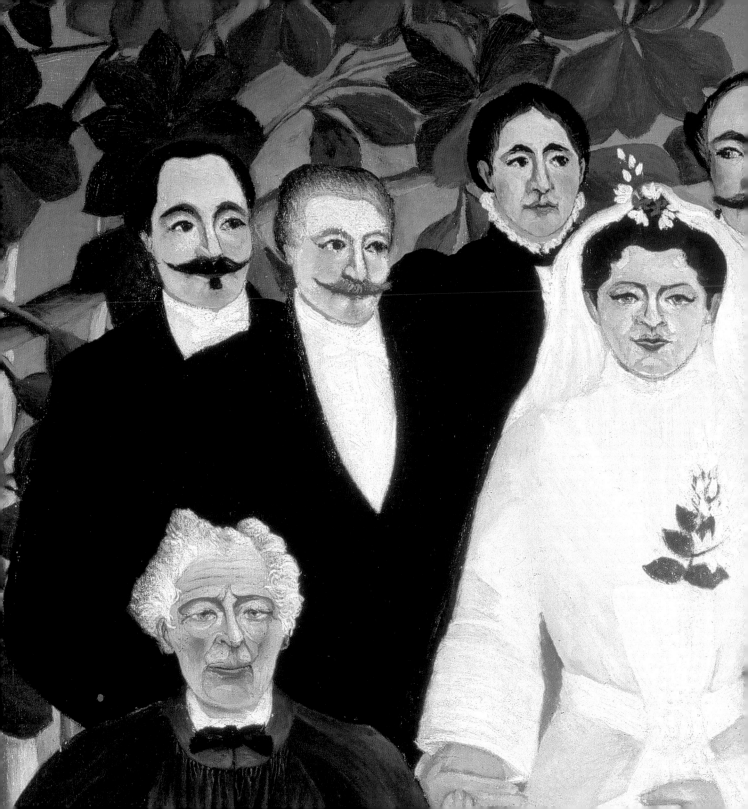

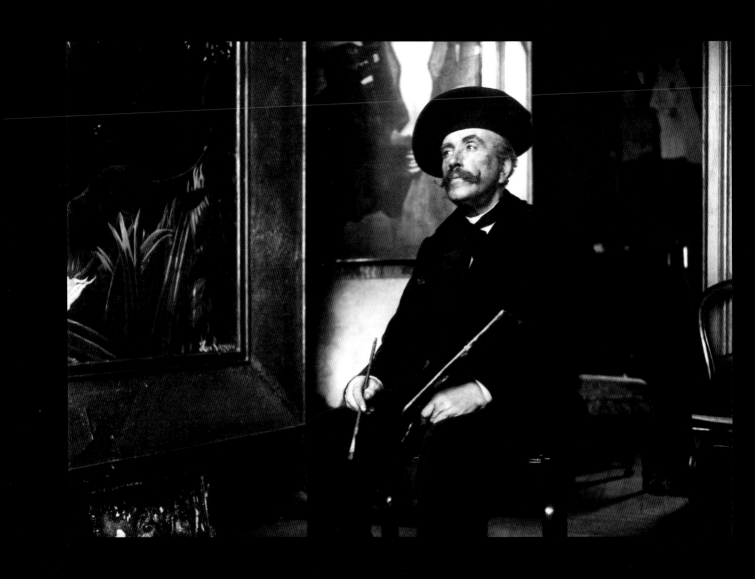

Rousseau and the 'Exotic'

I don't know if you are like me . . . but when I go
into the hothouses and I see all those strange plants
from exotic countries, it seems to me as though
I enter a dream![1]

Rousseau had always painted landscapes. Between 1890 and 1900 he
had submitted some twenty-six views of Paris and the surrounding areas
to the Indépendants; over the next ten years he would exhibit another
nineteen. But when he decided to show his works at the Salon d'Automne
in 1905, he made his debut not only with two small French views, but
also with a very different kind of landscape: a jungle scene. This was the
year – and the move – that was to change his artistic fortunes. His *The
Hungry Lion Throws itself on the Antelope* (fig. 8), displayed at the heart of
the exhibition alongside the works of 'Fauve' artists including Derain
and Vlaminck, attracted more attention than had any of his previous
creations. *Villa on the Outskirts of Paris* (fig. 6), submitted at the same time,
went unnoticed by the press. Perhaps this is unsurprising. How could
these canvases – an eye-catching, exotic scene of bestial combat versus a
sedate villa by a river – compete? At first glance they seem to have nothing
in common but, in the context of Rousseau's world, they make equal
sense.

However, if Rousseau was familiar with Paris and its suburbs, he could
not have known the wonders of the equatorial jungle from first-hand
experience. Although he may have claimed at certain moments or to
certain listeners that he took part in France's disastrous Mexican campaign,
in reality, he had never left the country.[2] The painter Othon Friesz recalled
that, when Rousseau recounted his 'American' experiences, it was clear to

33 Henri Rousseau in his studio
at Rue Perrel, Paris, 1907
Photo: Archives Larousse, Paris

all that he was lying.[3] Already, by 1921, Roch Grey would question whether he could really have kept memories of youthful travels alive so as to paint them in his jungle canvases some forty years later.[4]

Nevertheless, Rousseau's storytelling was probably based on something tangible, for it is likely that, during his time in the barracks at Angers, his fellow soldiers would have talked about their experiences overseas. Furthermore, even if this was not the case, he could have found such information elsewhere. The contemporary world furnished even ordinary civilians with a deluge of information concerning life beyond French shores. Indeed, in the most extreme of examples, the 'exotic', effectively, had arrived in Paris. The World Fair of 1889 – which Rousseau had visited so attentively in order to write his play – was a case in point. It had brought the 'sights' of the colonies and the rest of the globe – or at least a version of them – to the 'city of light'. Visitors must have felt as if they were experiencing something truly foreign: the impact of the displays upon a little-travelled urban population was surely overwhelming. To gain a sense of the wonders of faraway lands, then, the Parisian had simply to peruse the attractions of the city.

It was only two years after the 1889 Fair, in 1891, that Rousseau painted his earliest jungle scene. That image, the National Gallery's extraordinary *Tiger in a Tropical Storm (Surprised!)* (fig.5), was perhaps the most carefully executed image he ever produced. He described a tiger, pursuing an unseen prey, making its way through the undergrowth. The elaborate foliage, the meticulous sweeping lines that define the rainstorm, all make for an image that is both arresting and impressive. Here was Rousseau at his most 'accurate', for although he created the painting in his very particular style, the scene was plausible in a documentary sense. The sky is grey and atmospheric, the big cat – watched by, but ignorant of, its audience – reacts to the elements. The creature it follows, its victim, is invisible to the viewer, as though too small or too fast to appear in the glimpse of the scene provided by the painting. Additionally the artist seems to have given considerable thought to the task of describing the anatomy of the animal: its movement is unmistakably feline and the hairs on its back almost seem to bristle before the attack. If this was a fantastic scene, Rousseau described it as though it were real.

But could an artist, living in turn-of-the-century Paris, study a tiger from life? The answer, surprisingly, is yes. For over a century, the zoo in the Jardin des Plantes had provided city-dwellers with a taste of the faraway inside the city limits. Indeed, on the edge of the Latin Quarter, just a few moments walk from the river Seine, the Jardin featured a whole range of tropical plants and animals. There were hothouses (one bursting with tropical foliage [fig.36]), a large monkey house (fig.34) and a brand new aviary. And, in the unlikely event that this range of living species were insufficient to quell visitor curiosity, the ensemble was crowned with the impressive zoological galleries: the major attraction in this Muséum complex for scientific research into plant and animal species. There, inside the galleries, were new and astonishing stuffed animal exhibits, arranged following an orderly system of classification.[5]

Rousseau often went to the Jardin to draw. In 1910, when the art critic Arsène Alexandre interviewed him in his Rue Perrel studio, he explained that his travels had gone no further.[6] It is impossible, however, to know quite what aspects of the park attracted him. Weber recalled seeing drawings of 'birds, swans, animals and flowers' that the artist had made there – some perhaps dating back to as early as 1884 or 1886 – but sadly

34 Postcard of the Monkey Palace in the Muséum complex, 1900s

no examples survive.[7] However, the simple fact that *Surprised!* shows the tiger surrounded by tropical foliage suggests that Rousseau did not simply reproduce what he saw in the Jardin. Both animals and plants were on view, but there were no attempts to recreate a natural environment for any of the creatures save the birds. Wild cats and monkeys lived in cages devoid of vegetation; snakes, deprived of any kind of greenery, huddled under old hospital blankets.[8] The stuffed animals in the Muséum lived mostly under glass, similarly without any suggestion of their original habitat, in long and densely filled display cases (fig.35). In another part of the garden and without an animal in sight, creepers and cacti furnished elaborate greenhouses (fig.36).

The 'reality' of *Surprised!*, then, had very little to do with the literal reality of the Muséum. However, it did connect with the different kind of 'reality' promoted by the locality, the scientific wish to analyse the 'exotic'.

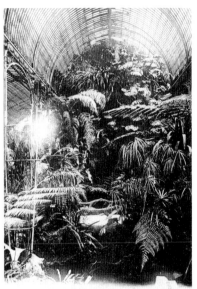

262. PARIS — JARDIN DES PLANTES · JARDIN D'HIVER

36 Postcard of the interior of the Winter Garden at the Jardin des Plantes, 1900s

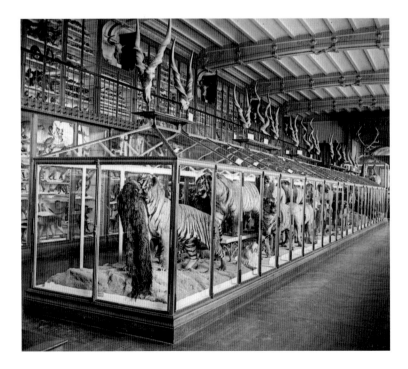

35 Henry Oliver
Zoological Gallery, Tiger Display
Digital print from a double glass negative
Ministère de la Culture, Médiathèque de l'Architecture et du Patrimoine, Paris

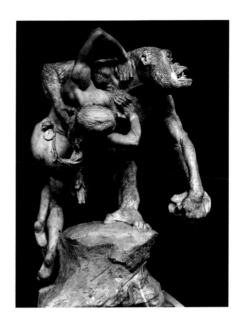

38 Emmanuel Frémiet
Gorilla 1887
Bronze patinated plaster
215 × 130 × 135
(84 $\frac{5}{8}$ × 51 $\frac{1}{8}$ × 53 $\frac{1}{8}$)
Fonds national d'art contemporain,
Ministère de la culture et de la
communication, Paris. Inv. 1117

37 Postcard showing Emmanuel Frémiet's **Bear Hunter** 1897, at the Jardin des Plants, 1900s

For even if the Jardin's method of display was to some extent dictated by the practical constraints of a limited budget, the lack of foliage in the cages did facilitate the concentrated study of animal anatomy.[9]

This spirit of scientific investigation at the Jardin des Plantes had already inspired many artists. Most notable among their number was the animal sculptor Emmanuel Frémiet who, in the last decades of the nineteenth century, created a variety of works depicting combats between humans and wild animals. Furthermore, as his case shows, public attitudes towards such work were changing. In 1859, his *Gorilla* (fig.38) had attracted censure at the Salon; but in a new climate of scientific investigation, the sculpture now won praise.[10] Crucially, if the situations he modelled were fantastic, the bodies of his animals were closely observed: so much so that in 1875, another of his works – the comparably violent *Stone-Age Man* – was installed in the Muséum grounds in close proximity to the real paleolithic displays. His *Bear Hunter* of 1897 – which was the subject of great praise at the 1900 World Fair – also found a place in the Jardin (fig.37). Perhaps these 'realistic' renditions of imaginary scenes encouraged Rousseau to create one of his own in *Surprised!* Needless to say, however, Rousseau's efforts produced an effect that was rather different from that achieved by Frémiet.

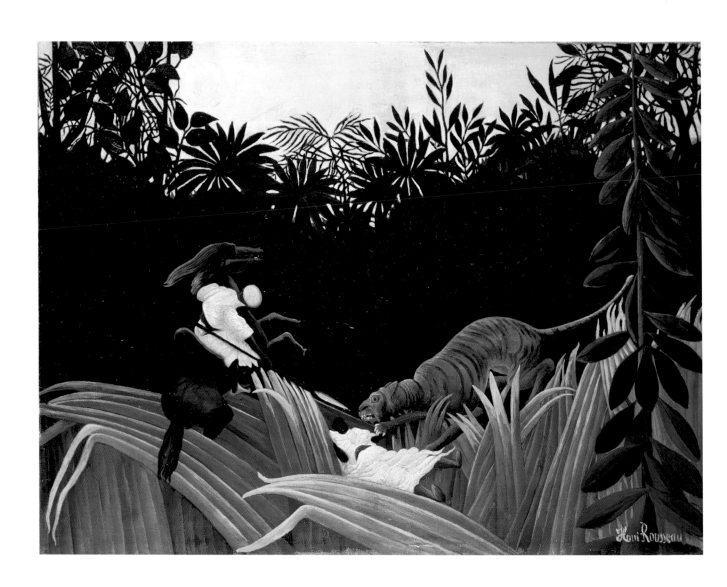

39 Scouts Attacked by a Tiger
1904
Oil on canvas
120.5 × 162 (47³/₈ × 63³/₄)
The Barnes Foundation,
Pennsylvania

Gaining nothing of that artist's success, for the remainder of the 1890s, Rousseau abandoned painting jungles almost entirely. By the time he did return to depicting the exotic in earnest, over ten years later, his approach had changed considerably. Now, the only 'real' thing that Rousseau aspired to project was a sense of fantasy.[11] In 1904 he showed his *Scouts Attacked by a Tiger* (fig.39) at the Indépendants, where, even if the reviews it attracted were not exactly complimentary, it was at least noticed.

Rousseau had, it seems, adapted his working methods according to the times; he must have been working along the right lines, for the following year he passed a jury selection for the first time, allowing him to show his *The Hungry Lion Throws itself on the Antelope* (fig.8) at the Salon d'Automne. In both these images – as in all of the jungle scenes that followed – Rousseau placed the 'characters' in the centre of the composition, like performers before an audience, in an arrangement of the kind used by contemporary filmmakers.[12] There is no longer any attempt at 'documentary' reality. Indeed, in the latter instance, the grouping seems to have been borrowed directly from one of the stuffed animal displays in the zoological galleries of the Muséum: a Senegal lion devouring its prey (fig.40). Gone is the moody sky of *Surprised!*; it is replaced in this image with a looming, deep red sun. Gone too are the cat-like qualities of the tiger; the lion and antelope in this work – the one with its macabre smile and the other shedding an enormous teardrop – are positively human in character. Rousseau added 'spectators' to the scene: an owl overhead looks on at the fierce battle while, in a tree to the left of the group, a panther waits for the lion to leave the spoils of its victory. The image – a 'collage' of compositional elements – is unashamedly fantastic.

The results are of this approach are – surprisingly – comparable to those that Rousseau achieved in his suburban landscapes. Just as works such as *Saw Mill* (fig.20) catered to the aspirations of his contemporaries who, being all too familiar with the problems of city life, looked to art for respite, his jungles now appealed to an audience who, tired of the endless classification of the 'exotic', now wished to reclaim it as a realm of escape.[13] Both his images of the outskirts of Paris and his foreign idylls could thus act as an antidote to the pressures of the contemporary world. Indeed, some of his exotic landscapes, such as *The Waterfall* (fig.41), which shows

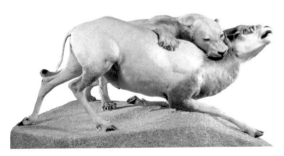

40 A Senegal lion devouring an antelope. Stuffed animal display, prepared for the 1889 opening of the Zoological Galleries

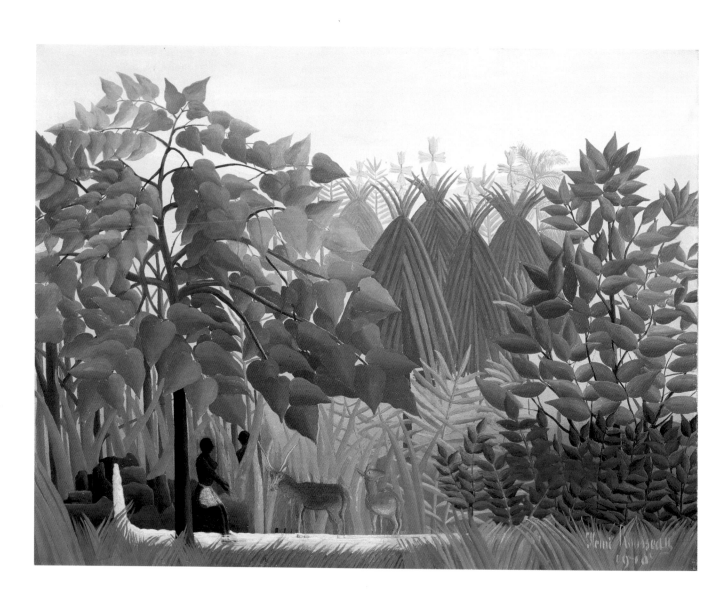

41 The Waterfall 1910
Oil on canvas
116.2 × 150.2 (45³/₄ × 59¹/₈)
The Art Institute of Chicago.
Helen Birch Bartlett Memorial
Collection

a jungle as peaceful as his *Jardin du Luxembourg* (fig.42), make the connection clearer still.

Critics of the day, for better or for worse, certainly saw that *The Hungry Lion Throws itself on the Antelope* (fig.8) was an extraordinary image. Writing for the journal *L'Evènement*, Camille Le Senne described the work as a 'quasi-prehistoric landscape' and concluded that the heavens must have furnished its author with 'a special mindset, that of the primitive artists who drew the profiles of oxen on the walls of caves'.[14] Another critic, having seen Rousseau's 1904 exhibits, declared that the painter possessed only 'embryonic intelligence'.[15] Certainly, by not conforming to normal 'civilised' modes of representing the exotic, Rousseau left himself open to the suggestion that he and his works were 'uncivilised' and perhaps even dangerous.[16] Admittedly, there is a sense of anarchic freedom in *The Merry Jesters* of 1906 (fig.44), where a group of monkeys play an unfathomable game with a milk bottle; likewise in his *The Repast of the*

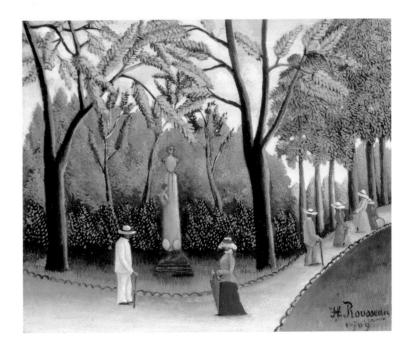

42 Jardin du Luxembourg 1909
Oil on canvas
38 × 47 (15 × 18¹/₂)
The State Hermitage Museum,
St Petersburg

Lion of *c.*1907 (fig.45), where, in a dense forest filled with the strangest of plants, a lion stands on its hind legs to sever the head of its prey. Viewers were wary of such curious works – a problem that was not helped by the idiosyncratic figure that Rousseau cut in the art world. Even Apollinaire, who would later be one of Rousseau's greatest defenders, wrote in 1908 that 'the "Customs Man" shows too great a lack of general culture. One cannot give oneself up to his ingenuity. One feels that there, there is something hazardous, ridiculous even.'[17]

Perhaps the 'ridiculousness' that Apollinaire feared resulted from the 'make-believe' element of Rousseau's work. Evidently, even if he had found his inspiration there, Rousseau had not painted the serious jungle of the botanical gardens. Instead, as his biographer Uhde wrote, the artist painted 'the virgin forest with its terrors and its beauties, which we dream of as children'. Here palm trees loomed under the silvery moonlight, trees grew like walls with giant black-green leaves, multi-coloured birds perched motionless in the branches. The long reeds of these landscapes might hide sleeping lions; monkeys play in the lush, green, canopy of Rousseau's forests. There is ambiguity, mystery, trepidation or bliss. 'This is not the virgin forest as it is played out for us on the cinema screen', Uhde concluded, 'but the virgin forest as a creation of fantasy.'[18]

However, if Rousseau's canvases now catered unashamedly to a taste for a fantastic version of the exotic, they were by no means alone. The popular illustrated press had long been producing gruesome scenes of animal-on-animal or animal-on-human combat (fig.43). It must have been clear to Rousseau's admirers that his works bore some similarity to the kind of material found in the *Le Petit Journal* and the *Petit Parisien*; the artist undoubtedly knew of its existence from his short stint as a sales representative for the former publication. But that 'popular' association made his work more interesting still to the avant-garde. Tiring of art-world intellectualism, they would soon discover the value of using newspapers in their own works; in the case of Picasso and his Cubist collages of 1911, quite literally.

Rousseau may well have hoped to please the young painters; it is interesting to note that he habitually sent 'exotic' works to the Salon d'Automne to show alongside theirs, while at the Indépendants his submissions

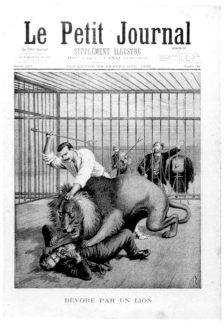

43 'Devoured by a Lion', illustration from **Le Petit Journal**, 29 September 1895

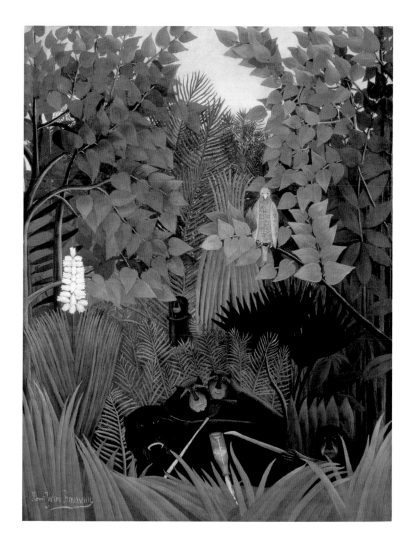

44 **The Merry Jesters** 1906
Oil on canvas
145.7 × 113.3 (57 3/8 × 44 5/8)
Philadelphia Museum of Art.
The Louise and Walter
Arensberg Collection, 1950

continued to be more varied. In 1907, for instance, at the Salon d'Automne he showed *The Snake Charmer*, a commission given to him by Delaunay's mother, along with two exotic landscapes and one French landscape. His larger submission at the Indépendants, in contrast, consisted of *The Representatives of Foreign Powers Coming to Greet the Republic as a Sign of Peace* (fig.46), three French landscapes, *The Present and the Past* of 1890 and a work entitled *Little Cherry-Pickers*. Clearly, however, he still hoped even his 'exotic' works might find official favour, that there might

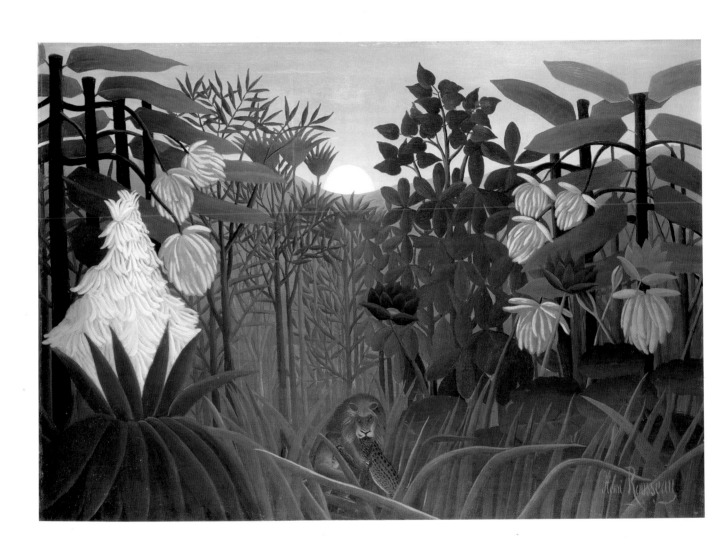

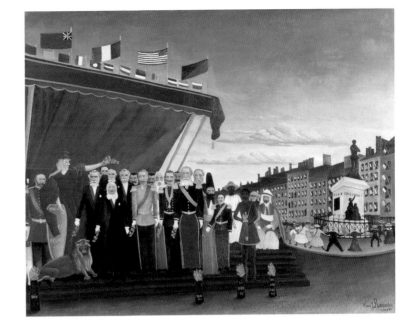

46 **The Representatives of Foreign Powers Coming to Greet the Republic as a Sign of Peace**
1907
Oil on canvas
130 × 161 (35⁵/₈ × 63³/₈)
Musée Picasso, Paris

45 **The Repast of the Lion**
c.1907
Oil on canvas
113.7 × 160 (44³/₄ × 63)
The Metropolitan Museum of
Art. Bequest of Sam A. Lewisohn,
1951 (51.112.5)

Overleaf: **The Waterfall** 1910
(detail of fig.41)

eventually be universal appreciation for all aspects of his work, for in 1908, when the new Mexican ambassador came to Paris, he tried in vain to sell him one of his jungle canvases.[19]

Sure enough, it was through his 'exotic' work – if not through state patronage – that Rousseau made his name. Slowly but surely, these were the paintings that helped him to develop an educated client base. In 1909, the dealers Ambrose Vollard and Wilhelm Uhde both bought works; so too did the collectors Ardengo Soffici and the Baroness D'Oettingen.[20] For these new patrons, since it was the fantastic aspects of his jungle pictures that mattered, Rousseau's character could only enhance his work. Here was an art that was new and refreshing; together with an artist who followed his own creative instincts. Rousseau, as they saw him, was true to a personal vision. That vision, furthermore, was a strong one. 'How to resist being taken in by a story so convincingly told?', asked the painter André Lhote. [21]

Rousseau and the Avant-Garde

The reputation of the 'customs man' Henri Rousseau
had extended from Plaisance to the more central parts
and beyond.[1]

Towards the end of his career, Rousseau's paintings began to have a
far-reaching impact. By 1910, respect for his art had grown considerably;
both artists and critics had learnt to embrace the idiosyncrasies of his
approach. That year he showed his largest ever canvas, *The Dream* (fig.1),
at the Indépendants. Here, fantasy was everything. The image even
appeared with a poem explaining as much: 'Yadigwha in a beautiful
dream/ Having fallen asleep softly / Heard the sound of a musette/
Played by a well-meaning charmer/ While the moon shone down /
On the flowers, the verdant trees/ The wild serpents lent their ear/
To the merry tunes of the instrument.'[2] It was in this way that Rousseau
painted the mythical muse of his youth upon a red sofa, transported to a
jungle setting and transfixed by a pipe-player, surveyed by a whole variety
of creatures. Even an elephant, peeking through the trees, joins the
assembled company. Suitably impressed, Apollinaire predicted that
this year, no one would laugh. 'Ask the painters', he added, 'they are in
admiration.'[3] And although Rousseau's picture did cause amusement
in some quarters, when it came to summarising the reaction of 'the
painters', the poet was right.

But regrettably, Rousseau would not live to enjoy his newfound
success for long; he died that autumn, at the age of sixty-six. His death
was not sudden, but it seems to have taken his admirers by surprise. He
had been suffering from a leg wound, perhaps even for a few months,

which had become infected. Apollinaire, in a poem of 1914, remembered how the artist showed him 'those bloody holes' on a fine spring morning, as they were taking a drink in a café on the Rue de la Gaîté.[4] The two had been friends for some time and, since the poet had sat for Rousseau in the summer of 1908, they had kept up a regular correspondence.[5] Perhaps, since the leg wound evidently did not prevent him from socialising, the artist's health problems had seemed less serious than they really were. Rousseau was optimistic; he may well have convinced his friends that there was no need for concern. Even when Uhde visited the studio on a hot August day, finding him bedridden and lacking the energy to brush away the flies that kept landing on his face, the topic of conversation was still work.[6] Perhaps to the painter, in a lifetime littered with misfortunes, illness simply presented itself as another setback to be overcome.

Thus, apart from his extraordinary paintings, the young avant-garde also found Rousseau's determination inspirational. Delaunay praised the way in which his friend painted, 'with the attention to detail of a worker, who loves his job passionately at every moment'.[7] As many saw it, he used technique simply as a practical way of expressing his vision or his feelings, never changing it to suit his subject matter.[8] Some admirers felt that this made Rousseau's art more truthful; in his fantastic landscapes, like in his portraits, he captured much more than appearance. As Uhde wrote, 'A painting by Henri Rousseau is not a simple record of how the eye reacts to, or how feelings are affected under, the influence of this tone or that shade.'[9] But what did Rousseau capture in his canvases?

In his jungle pictures, certainly, he managed to synthesise the narrative of a scene into a single depicted image. In *Horse Attacked by a Jaguar* of 1910 (fig. 49), for example, the big cat's lethal pounce coincides with both the victim's struggle and the victor's feast. Observing the way in which Rousseau condensed information in his work, the Dada writer Tristan Tzara put together an important hypothesis, suggesting that his pictures captured the experience of modern life itself.[10] Overloaded with visual information, the modern mind is forced to summarise, to make sense of a situation so as to describe it effectively. This, he argued, is the strategy that underlies Rousseau's work. He identified it in many paintings

49 **Horse Attacked by a Jaguar**
1910
Oil on canvas
89 × 116 (35 × 45 5/8)
The State Pushkin Museum of Fine Arts, Moscow

besides the jungle scenes, showing how *The Football Players* of 1908 (fig.51) gives a sense of watching a match, with its players frozen in poses that suggest different stages of the game. There, the extraordinary composition and the strange perspective encourage the eye to move around the picture plane; instead of *describing* how the players run in a game of football, the painting gives a sense of the match actually happening. There is no fixed point of focus, as is the case when watching a sporting event.

The same effect can be seen in Rousseau's *View of Malakoff, Paris Region* (fig.50). In this picture, instead of simply depicting how a windswept landscape looks, the artist conveyed a sense of what is was like to be part of the scene. In that work, the strong wind is suggested by the telegraph poles, which bend as though prey to the forces of nature. Of course, in an age of new technology, cinema and photography were far better equipped to record the effects of the elements literally. With his painting, however, Rousseau suggested an alternative role for art: one of conveying an experience as it is *felt*. If the results achieved by this approach were sometimes baffling, then the 'modernity' was all the more pronounced. His *Old Junier's Cart* (fig.53), for example, may be difficult to make sense of; but if it seems dislocated and fragmentary perhaps so too did contemporary life. Thus although many of Rousseau's images included new motifs – such as his *Ivry Quay* with its cast of flying machines (fig.52) – it was not these images that best demonstrated how his art was of its time. Because they demonstrated a new way of seeing and summarising, even the most 'timeless' or anachronistic images that Rousseau created – such as his *Eve* of *c*.1906–7 (fig.54) – reflected the epoch in which they were made.

Here, then, was an artist who fully participated in his age. In fact, Rousseau was familiar with many facets of Parisian life, not least the legal system. In the winter of 1907, he had become embroiled in an elaborate case of bank fraud, which eventually led to him spending another spell in prison.[11] The case was a curious one: a man with whom the painter had played in a local orchestra, Louis Sauvaget, persuaded him to go to a bank in a provincial town and open an account under a false name. Rousseau did this, though not without some trouble, for he had to abandon his first

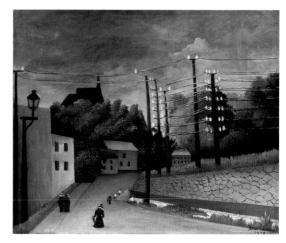

50 **View of Malakoff, Paris Region** 1908
Oil on canvas
46 × 55 (18 1/8 × 21 5/8)
Private Collection,
Courtesy Pieter Coray

51 The Football Players 1908
Oil on canvas
100.5 × 80.3 (39 1/2 × 31 3/8)
Solomon R. Guggenheim,
New York, 60.1583

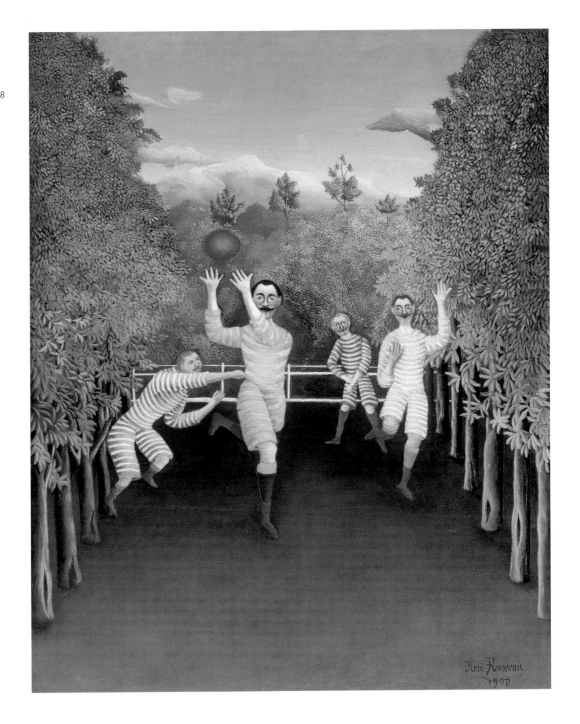

attempts. But upon succeeding, again under the orders of his accomplice, he visited a printer where he had a series of dockets made to mimic those of the Bank of France. Sauvaget, who worked as a clerk in a Paris branch of the same bank, then completed one of these. The docket requested that a 21,000 franc payment be made to an out-of-town client. Of course, that client was Rousseau, under his false identity. For his involvement in the deception, Sauvaget awarded the artist 1,000 francs, keeping the remainder himself.

The details of the fraud are intricate, but even a brief account shows that Rousseau was probably aware of the fact that his actions were illegal. The crime was soon discovered; the perpetrators were arrested and sent to prison. But, interestingly, faced with the dilemma, the painter would rely on his 'naive' reputation for his defence. Rousseau's case rested on the

53 **Old Junier's Cart** 1908
Oil on canvas
97 × 129 (38 1/8 × 50 3/4)
Musée de l'Orangerie, Paris

52 **Ivry Quay** c.1907
Oil on canvas
46 × 55 (18 1/8 × 21 5/8)
Bridgestone Museum of Art,
Tokyo, Ishibashi Foundation

54 **Eve** *c.*1906–7
Oil on canvas
61 × 46 (24 × 18 1/8)
Hamburger Kunsthalle,
Dauerleihgabe der Stiftung zur
Förderung der Hamburgischen
Kunstsammlungen

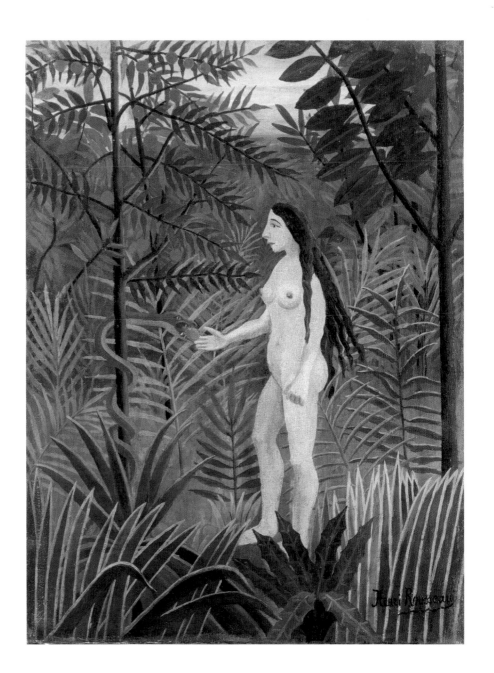

fact that his former friend had duped him. From prison, he wrote letters to the judge protesting his innocence, explaining how he had not known that he was doing wrong. 'People have always told me that I have a weak character', he wrote ruefully.[12] He also stressed how important it was that he should get back to work, how he had classes to teach. These letters – deliberately or not – reinforced the idea that the artist was simple. In one, without even acknowledging the impracticalities it might involve, he explained how he needed to collect his pension!

When the case went to trial, in January of 1908, the stereotypical image of Rousseau as naive was played out in the courtroom. The proceedings, by all accounts, unfolded like a comic opera. The press, who covered the affair, consolidated the readings of Rousseau's character that it produced. The defence paraded Rousseau's paintings and his scrapbooks as evidence in his favour; everything the artist said made the assembled company laugh. 'Do not condemn a "primitive"!' pleaded his lawyer to the jury.[13] The judge remained sceptical, but nevertheless, Rousseau was let off with a small fine and a suspended sentence.

Later that year, Picasso threw a party in Rousseau's honour, at his studio in the Rue Ravignan.[14] The guest list – had it been that formal an affair – would have read impressively. The young painters and poets of Paris came to celebrate 'Le Douanier'; Georges Braque, Max Jacob and André Salmon, were just a few of those who attended. The event became known as the 'Banquet Rousseau', but it was hardly a feast, since the host had mistakenly ordered the meal for delivery the following day. The various accounts of the evening, however, reveal that there had been plenty of wine to drink. A party atmosphere reigned throughout. Having found what provisions they could, the guests feasted on such culinary delights as tinned sardines, while later, Rousseau played his violin and danced with the women. Undoubtedly, there was an element of amusement in this homage to the old painter, but the respect that the young artists had for his work was sincere.[15]

The avant-garde may simply have wanted to believe in the myth of Rousseau's naivety because it made him seem more poetic.[16] Whether they could really have thought of him as completely unworldly is questionable; along with such surprises as his involvement in bank

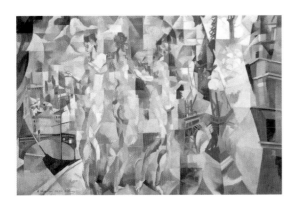

55 Robert Delaunay
The City of Paris 1910–12
Oil on canvas
267 × 406 (105 1/8 × 159 7/8)
Musée national d'art moderne,
Centre Georges Pompidou, Paris

fraud, it is true that Rousseau could sometimes surprise the bohemian intelligensia with his points of view. The painter Albert Gleizes, for instance, remembered how, at meetings at the studio of Henri Le Fauconnier, Rousseau would come along and add quite unexpected comments to the discussions about literature and other topics.[17]

Following his death, the esteem that the younger generation held for the artist became all the more apparent. Upon learning of the loss of his friend, Weber, then in New York, promptly organised the first proper Rousseau exhibition, at the 291 Gallery. Back in France, in the spring of 1911, Delaunay organised a major retrospective of the artist's work at the Indépendants. More importantly, in the surrounding galleries of that salon, Rousseau's influence was visible in some of the new paintings of the younger generation. This was the year in which Delaunay showed his *The City of Paris* (fig.55) where, in the bottom left hand-corner, he quoted from Rousseau's iconic 'portrait-landscape' (fig.15).

But Delaunay was unusual in placing a section of an image by Rousseau in his own canvas. More often the older artist's influence upon other painters was far less straightforwardly recognisable. Picasso and Fernand Léger, Giorgio de Chirico and Wassily Kandinsky, to name but a few, all engaged with Rousseau's approach to painting in very different ways, learning from his use of everyday motifs and his unpretentious style.[18] Picasso, for instance, would borrow the idea of using 'popular' material; Léger would employ dense outlines, recalling the solidity and the unashamedly figurative qualities of Rousseau's portraits.[19] Meanwhile, de Chirico would pick up on the theme of memory in the artist's work,[20] while Kandinsky, casting Rousseau amongst the heroes of his newly established Blaüe Reiter (Blue Rider) group, looked to him as a model for a simplistic approach to making art.[21] Indeed, almost all of these artists would probably have agreed with another painter, André Derain, when he said that 'It is really quite simple … hang a Rousseau between two old or new paintings; two good paintings; the Rousseau will always give the stronger impression.'[22]

Overleaf: **Horse Attacked by a Jaguar** 1910 (detail of fig.49)

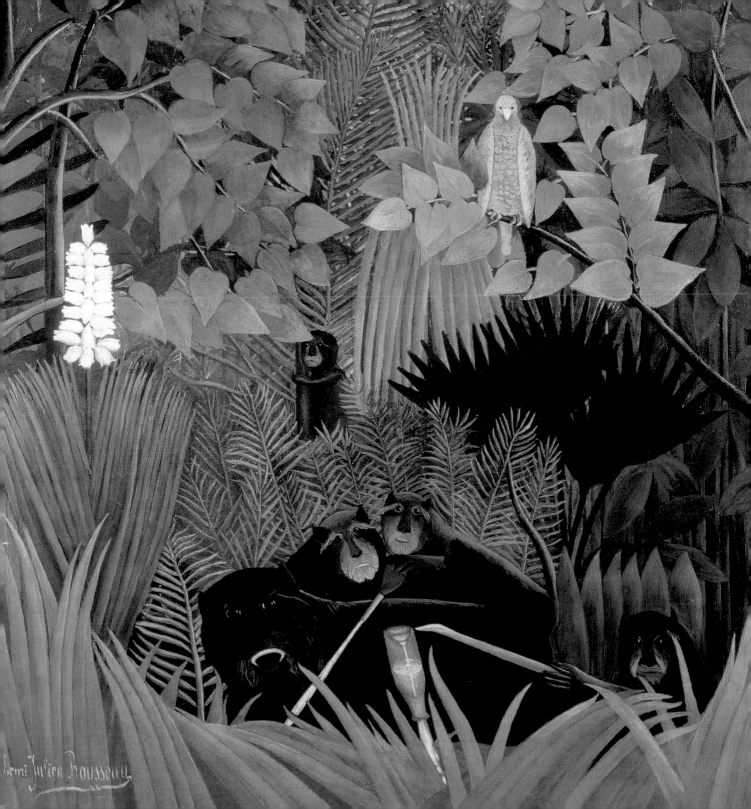

The Significance of Rousseau

Glorious and maladroit, awkward and elegant, the work
of Henri Rousseau defies all domineering or dogmatic
criticism . . . One needs sense to understand. That is, one
needs to be sensual, to feel and to live every work – so
that the adventure can become a part of the continuous
chain of sensations that is life.[1]

Following the praise of the young painters and poets, collectors and
institutions would soon come to embrace Rousseau and his work. 'Le
Douanier' was finally accepted by the art scene. As clear as the blue sky of
one of his suburban landscapes, as fantastic as a smiling lion, Rousseau's
painting seemed singularly uncomplicated. 'With Rousseau, there is
no theory, no rhetoric. He is all sensitivity and sense of style', wrote
Delaunay.[2]

It is still easy to enjoy his works, with their bright colours and their
extraordinary character combinations, at face value: but they do offer
more than this straight-forward visual appeal. They reveal much about
the time at which the artist painted, about the kind of people he lived
amongst, about the conventions and prejudices he challenged. They
informed the art of a younger generation and continue – even today – to
inspire artists. Therefore, while it is important that his paintings 'will
always fill our eyes with wonder', it is nonetheless essential to consider
them in all their complexity.[3] Interpreting Rousseau is not just about
looking: it is about finding out what might be there.

The Merry Jesters 1906 (detail of fig.44)

Notes

INTRODUCTION: A MAN
AND A MYTH

1 Guillaume Apollinaire, poem created for Rousseau's monument. The lack of punctuation in this translation reflects the poet's style.
2 The list of those involved in the transferral appears in an unpublished note, written by Robert Delaunay in the Fonds Delaunay, Centre Georges Pompidou, Box 61.
3 Wilhelm Uhde, *Henri Rousseau*, Paris 1911, p.56.
4 Robert Delaunay, *Du Cubisme à l'art abstrait*, Paris 1957, p.193.
5 André Salmon, *Henri Rousseau dit le Douanier*, Paris 1927, p.18.
6 Robert Delaunay, 'Mon ami Henri Rousseau' (part 3), *Tous les Arts*, 28 August 1952, p.7.

ROUSSEAU'S EARLY YEARS

1 Christian Zervos, *Rousseau*, Paris 1927, p.7.
2 Christopher Green explores the relationship between Picasso and Rousseau in 'The Great and the Small: Picasso, Henri Rousseau and "The People"', *Picasso: Architecture and Vertigo*, New Haven and London, forthcoming.
3 The best modern biography of Rousseau remains Henri Certigny, *La Vérité sur le Douanier Rousseau*, Paris 1961. Much of the biographical information in this book is adapted from that source. Maximillien Gauthier discusses Rousseau's maternal genealogy, (*Henri Rousseau*, Paris 1949, p.6).
4 Rousseau wrote an autobiographical note as a contribution to an unpublished book, 'Portraits for the Coming century'. This is reproduced in *Henri*

Rousseau, exh.cat., MoMA, New York 1985, p.256.
5 Details of the court report cited in Henri Certigny, *La Vérité sur le Douanier Rousseau*, Paris 1961, p.62
6 For details of rural migration during the years of the Third Republic see J.M. Myeur and M. Reberioux, *The Third Republic: From its Origins to the Great War*, trans. J. Forster, Cambridge 1984, pp.44–64.
7 Max Weber, 'Rousseau as I knew him', typed manuscript prepared for lecture given at the Art Institute of Chicago, 1942, p.2. Cited in Sandra Leonard, *Henri Rousseau and Max Weber*, New York 1970, p.16.
8 Philippe Soupault, 'La légende du Douanier Rousseau', *L'Amour de l'art*, vol.7, no.10, Paris 1926, p.334.
9 Henri Rousseau, *L'Etudiant en goguette*, poss. before 1889, unpublished typescript (made by Tzara). Fonds Tristan Tzara, Paris, Bibliothèque Jacques Doucet Littéraire, T2R 762. For an analysis of the work see Nancy Ireson, 'Tristan Tzara and the plays of the Douanier Rousseau', *Burlington Magazine*, September 2004, pp.616–21.
10 Certigny 1961, pp.102–3
11 Rousseau wrote to the art critic André Dupont to explain that 'M.Gérome' had encouraged him in his chosen style of painting. The letter was reproduced in *Les Soirées de Paris*, 15 January 1914, p.57.
12 A. Boime, 'Jean-Léon Gérôme, Henri Rousseau's *Sleeping Gypsy* and the Academic Legacy', *Art Quarterly*, vol.34, no.1, Detroit 1971.
13 Pierre Vaisse, *La Troisième République et les Peintres*, Paris 1995, pp.28–9.
14 *Le triomphe des mairies* (exh.cat., Réunion des Musées Nationaux, Paris 1986, p.238) discusses the

replacement of religious festivals with Republican equivalents.
15 Henri Certigny, 'L'Attaque de Bagnolet', *La Vérité sur le Douanier Rousseau*, Paris 1961, pp.126–9. For details of Rousseau's appointment to the *Octroi* see pp.76–9.
16 Robert Delaunay, 'Mon ami Henri Rousseau' (part 2), *Tous les Arts*, 21 August 1952, p.9.
17 Louis Roy, 'Un Isolé: Henri Rousseau', *Mercure de France*, March 1895, pp.350–1 For Jarry and Rousseau see Jill Fell, 'Jarry: An imagination in revolt', Ph.D. dissertation, University of Bristol, 1997, pp.224–34.

ART AND LIFE IN PARIS

1 Philippe Soupault, 'La légende du Douanier Rousseau', *L'Amour de l'Art*, vol.7, no.10, Paris 1926, p.334.
2 Letter from Henri Rousseau to the Mayor of Laval, 10 July 1898 conserved in the documentation of the Musée de Vieux Chateau, Laval.
3 Christian Zervos, *Rousseau*, Paris 1927, pp.20–1.
4 Maurice Aghulon (*Marianne au Pouvoir: l'Imagerie et la symbolique Républicanes de 1880 à 1914*, p.146) mentions how 'ordinary' Rousseau's Republicanism was.
5 Uhde 1911, p.41.
6 Henri Rousseau, *Une Visite à l'Exposition de 1889*, Geneva 1947, p.81.
7 Robert Delaunay, 'Mon ami Henri Rousseau' (part 2), *Tous les Arts*, 21 August 1952, p.9.
8 Tristan Tzara, preface to Henri Rousseau, *Une Visite à l'Exposition de 1889*, Geneva, 1947, p.9.
9 Henri Rousseau, *La Vengeance d'une orpheline russe*, Geneva 1947.

10 Eventually Tristan Tzara took on the task of publishing Rousseau's plays in 1947. For details see Nancy Ireson, 'Tristan Tzara and the plays of the Douanier Rousseau', *Burlington Magazine*, no.1218, September 2004, pp.616–21.
11 Christopher Green discusses Rousseau's work in relation to the 'carte de visite' photographs in 'The Great and the Small: Picasso, Henri Rousseau and "The People"', *Picasso: Architecture and Vertigo*, New Haven and London, forthcoming.
12 Uhde 1911, p.21.
13 André Salmon, *Henri Rousseau dit le Douanier*, Paris 1927, p.8.
14 The poem mentioned appears amongst the poems by Rousseau that Apollinaire published in *Les Soirées de Paris* (15 January 1914, p.65) entitled *Inscription pour un portrait dans un paysage*.
15 Uhde 1911, pp.12–13, for example, describes the disdain of one of Rousseau's former colleagues.
16 This note is now in the documentation of the Musée de Vieux Chateau, Laval.
17 Roch Grey, *Henri Rousseau*, Rome 1924, p.20.
18 Uhde 1911, p.11.
19 Roch Grey, 'Souvenir de Rousseau, *Les Soirées de Paris*, p.66. Uhde 1911, p.16.
20 Programme reproduced in *Les Soirées de Paris*, 15 January 1914, pp.14–16.
21 Max Weber, 'Rousseau as I knew him', typed manuscript prepared for lecture at the Art Institute of Chicago, 1942, p.25, cited in Sandra Leonard, *Henri Rousseau and Max Weber*, New York 1970, p.40.

ROUSSEAU AND THE 'EXOTIC'

1 Henri Rousseau, interviewed by Arsène Alexandre, 'La vie et l'oeuvre d'Henri Rousseau: Peintre et ancien employé de l'octroi', *Comoedia*, no.901, 10 March 1910, p.3.
2 Documentary evidence for this and many other details of Rousseau's biography were gathered by Henri Certigny in *La Vérité sur le Douanier Rousseau*, Paris 1961. This remains the most comprehensive biography of the artist.
3 Recounted by Maximilien Gauthier, *Henri Rousseau*, Paris 1949, p.10.
4 Roch Grey, 'Henri Rousseau', *Action*, no.7, May 1921, p.10.
5 For details of the *Jardin des Plantes* in Rousseau's day, see Christopher Green, 'Souvenirs of the Jardin des Plantes: Making the Exotic Strange Again', *Henri Rousseau: Jungles in Paris*, exh.cat., Tate, 2005.
6 Alexandre 1910.
7 Max Weber, typed manuscript of unpublished memoirs, 'Rousseau as I knew him', c.1942 p.51. Courtesy of Joy Weber.
8 Roch Grey, 'Henri Rousseau', *Action*, no.7, May 1921, p.11.
9 Christopher Green 2005, p.33
10 Philippe Dagen, *Le Peintre, Le poète, le sauvage: les voies du primitivisme dans l'art français*, Paris 1998, p.13.
11 This idea is explored in Vincent Gille, 'Illusion of Sources – Sources of Illusion: Rousseau Through the Images of His Time', *Henri Rousseau: Jungles in Paris*, exh.cat., Tate, 2005.
12 Rousseau's work is compared to that of early French filmmakers in Richard Abel, *The Ciné goes to town: French cinema 1896–1914*, California, 1994, p.72
13 See Green 2005, pp.40–1, for an exploration of the 'escape' offered by Rousseau's exotic landscapes.
14 Camille Le Senne, *L'Evénément*, 18 October 1905.
15 Francis Lepeseur (Emile Bernard), 'L'Anarchie Artistique', *La Rénovation Esthétique*, June 1905, p.92. Thanks to Richard Shiff for identifying the author.
16 This idea is explored in Nancy Ireson, 'Le Douanier as Medium? Henri Rousseau and Spiritualism', *Apollo*, no.508, June 2004, pp.80–7.
17 Apollinaire, 'Le Salon des Indépendants', *La revue des Lettres et des Arts*, 1 May 1908, reproduced in *Chroniques de l'art 1902–1918*, Paris, 1960, p.70.
18 Uhde 1911, p.43.
19 Max Weber, typed manuscript of unpublished memoirs, 'Rousseau as I knew him' c.1942, p.51, Courtesy of Joy Weber.
20 Rousseau's account book was reproduced in Robert Delaunay, 'Mon ami Henri Rousseau' (part 4), *Tous les Arts*, 4 September 1952, p.10.
21 André Lhote, 'Henri Rousseau' 1923, *Parlons Peinture: Essais*, Paris 1933, p.310.

ROUSSEAU AND THE AVANT-GARDE

1 Georg Pauli, the Swedish painter, recalling his stay in Paris: 'Paris 1910' in *Paris den nya konstens kålla. Antecknigar ur dagböcker och brev*, Stockholm 1915, p.29. My thanks to Vibeke Röstorp for alerting me to this source.
2 Uhde 1911, p.65.
3 Guillaume Apollinaire, *L'Intransigeant*, Paris, 20 March 1910, reproduced in *Chroniques d'Art*, Paris 1960, p.97.
4 Guillaume Apollinaire, 'Souvenir du Douanier', *Les Soirées de Paris*, Paris, 13 August 1914.
5 The letters that Rousseau sent to Guillaume Apollinaire appear in 'Le Douanier', *Les Soirées de Paris*, 15 January 1914, pp.30–61.
6 Uhde 1911, p.24.
7 Robert Delaunay, 'Mon Ami Henri Rousseau' (part 2), *Tous les Arts*, 21 August 1952.
8 Tristan Tzara, preface to Henri Rousseau, *Une Visite à l'Exposition de 1889*, Geneva 1947, p.9.
9 Wilhelm Uhde, *Henri Rousseau*, exh. cat., Bernheim-Jeune et Cie, Paris, 1912.
10 Tzara 1947, pp.16–17.
11 The brief summary of the affair that follows is based on the detailed account given in Maurice Garçon, *Le Douanier Rousseau: Accusé naïf*, Paris 1953.
12 Letter from Rousseau to the *joge d'instruction*, 5 December 1907, reproduced in Garçon 1953, p.14.
13 'Ne condamnez pas un primitif!' was the phrase recorded by the reporter for *Le Petit Journal*. Cited in Garçon 1953, p.26.
14 There are several accounts of the 'Banquet Rousseau'; this description is based on that of Maurice Rayanal in *Les Soirées de Paris*, 15 January 1914, pp.69–72.
15 Christopher Green makes this point in 'The Great and the Small: Picasso, Henri Rousseau and "The People"', *Picasso, Architecture and Vertigo*, New Haven and London, forthcoming.
16 Christopher Green 2005, p.47
17 Albert Gleizes, *Souveniers: le Cubisme 1908–1914*, Ampuis 1997, p.9.
18 Carol Lanchner, William Rubin, 'Henri Rousseau and Modernism', *Henri Rousseau*, New York 1985, pp.35–89. Gotz Adriani also drew some interesting comparisons between the works of Rousseau and the avant-garde in *Henri Rousseau: Der Zöllner – Grenzgänger zur Moderne*, Tübingen 2001.
19 Christopher Green, *Léger and the Avant-Garde*, New Haven 1976, pp.10–11.
20 Antonio del Guercio, *Parisien Malgré lui: De Chirico 1911–1915*, Paris 1997, pp.59–61.
21 Wassily Kandinsky, 'On the Question of Form', *The Blaüe Reiter Almanac*, ed. Wassily Kandinsky and Franz Marc, English trans. H. Falkenstein, London 1974, p.178.
22 André Derain cited by Maximilien Gauthier, *Henri Rousseau*, Paris 1949, p.21.

CONCLUSION: THE SIGNIFICANCE OF ROUSSEAU

1 Blaise Cendrars, 'Le Douanier Henri Rousseau', *Der Sturm*, nos.178–9, September 1913. Reprinted Nendeln/ Liechenstein 1970, p.99.
2 Robert Delaunay, 'Mon ami Henri Rousseau' (part 1), *Tous les Arts*, 7 August 1952, p.9.
3 Paul Eluard use this phrase to describe Rousseau's appeal in 'Henri Rousseau le Douanier', *Henri Rousseau le Douanier*, Paris 1944, p.4.

Index